VICTORIAN PHOTOGRAPHS

VICTORIAN PHOTOGRAPHS OF FAMOUS MEN & FAIR WOMEN
BY JULIA MARGARET CAMERON

With Introductions by
VIRGINIA WOOLF & ROGER FRY

Expanded and Revised Edition Edited by
TRISTRAM POWELL

DAVID R. GODINE
Publisher
Boston

DAVID R. GODINE
Publisher
Boston, Massachusetts

First published 1926
This edition with additional
photographs and Preface 1973

LCC 73–81062

ISBN 0 87923 076 2

© The Hogarth Press 1973
Preface and Notes © Tristram Powell 1973

Printed in England by W. S. Cowell Ltd,
at the Butter Market, Ipswich

CONTENTS

PLATES

PLATES

PREFACE

By Tristram Powell

'Victorian Photographs of Famous Men and Fair Women by Julia Margaret Cameron' was first published in 1926. The book contained Virginia Woolf's entertaining account of her great-aunt, and Roger Fry's analysis of Mrs. Cameron's photographs which was well ahead of its time in appreciating some of the virtues of photography. This new edition contains twenty-three new studies and some further biographical material.

<p align="center">* * *</p>

Mrs. Cameron recorded her first successful photograph in 1864 when she was forty-nine. Photography proved to be the perfect outlet for her talents, part artistic, part social, and from that date until her death in Ceylon in 1879, she persuaded or commanded family, friends, servants, the famous, or just passers-by whom she spotted from her window, to pose before her camera.

In 1874, she wrote a biographical fragment 'Annals of My Glass House', in which, with characteristic emotion, she describes her early struggles:

"Therefore it is with effort that I restrain the overflow of my heart and simply state that my first lens was given to me by my cherished departed daughter and her husband, with the words, 'It may amuse, Mother, to try to photograph during your solitude at Freshwater.'

"The gift from those I loved so tenderly added more and more impulse to my deeply seated love of the beautiful, and from the first moment I handled my lens with a tender ardour, and it has become to me as a living thing, with voice and memory and creative vigour. Many and many a week in the year '64 I worked fruitlessly, but not hopelessly—

> *A crown of hopes*
> *That sought to sow themselves like winged lies*
> *Born out of everything I heard and saw*
> *Fluttered about my senses and my soul.*

"I longed to arrest all beauty that came before me, and at length the longing has been satisfied. Its difficulty enhanced the value of the pursuit. I began with no knowledge of the art. I did not know where to place my dark box, how to focus my sitter, and my first picture I effaced to my consternation by rubbing my hand over the filmy side of the glass.

"I believe that what my youngest boy, Henry Herschel, who is now himself a very remarkable photographer, told me is quite true—that my first successes

<p align="center">9</p>

in my out-of-focus pictures were a fluke. That is to say, that when focusing and coming to something which, to my eye, was very beautiful, I stopped there instead of screwing on the lens to the more definite focus which all other photographers insist upon."

Although she began as an amateur, Mrs. Cameron ended up a self-conscious artist. She knew that the chancy out-of-focus effect, which became her hallmark, could enhance the beauty of a print. She would make many versions of a print to reach a precise effect (the head of Mrs. Herbert Duckworth for example), and if she was sometimes haphazard in the application of chemicals, she also knew that technical flaws in reproduction meant nothing if the mood and character of the picture were right. She did not believe in retouching. "From life, registered photograph" would generally be written on the mount, together with her signature and the date. She had, in fact, a strong sense of the originality and value of her work.

The force of personality which strikes us in her best pictures, combined with her choice of subject, has given her work a coherence which is lacking in less personal photographers. An intensity of feeling is transmitted to the sitter and one has only to compare her pictures with conventional studio photographs of the period to see how uninhibited she was and how differently she reacted to each of her sitters. Her portraits of famous men do, it is true, enshrine a monumental view of human personality. Mrs. Cameron believed that great thoughts shone, like haloes, from the heads of her thinkers, so her pictures are acts of homage towards her heroes. She would not allow a word of criticism of the roles in life which her sitters had assumed, or which she had imposed on them for the length of the photograph. And indeed she never really forgave the poet William Allingham for not being wholly enthusiastic about the verse of her friend, the much photographed Sir Henry Taylor, whom she worshipped.

William Allingham clearly found Mrs. Cameron's commanding manner and eccentricities, however genuine, rather irritating. When Rossetti came to stay with Allingham at Freshwater Bay, several pressing notes arrived inviting them both over to be photographed. The answer was decidedly "No." Edward Lear also failed to make friends with Mrs. Cameron. "Mrs. Cameron only came in once—with feminine perception not delighting in your humble servant," Lear wrote to Holman Hunt after a visit to the Tennysons.[1] "We jarred and sparred and she came no more." Not everyone fell for Mrs. Cameron's charm.

No other early photographer, except perhaps Fox-Talbot, has conveyed so clearly the excitement of experimenting with the camera, and the attempt to make full use of the characteristics inherent in what must have seemed a magical new medium. The wistful air which hangs over many of her photographic portraits is like a last look back to the days of the painted portrait, a last attempt to transmit the

[1]*Edward Lear* by Angus Davidson (Murray, 1938).

aura of the great figures of the time by the medium which was turning painting upside down. Her camera, and those of a few other early photographers, signal the decline of portrait painting as straightforward representation. If Mrs. Cameron's response to her sitters still has something of the painter about it, she is also aware of the ability of the camera, on one level, to record without comment. Her best photographs combine the non-committal surface accuracy, unique to photography, with an underlying search for the "Ideal". She looked at her sitters with determined optimism. Our mood may be different, but her photographs still retain their beauty and poignancy, also the odd touch of wildness and eccentricity, which tended to be ironed out in painted portraits of the period, but which Mrs. Cameron, however great her admiration for the sitter, cannot quite disguise.

MRS. CAMERON'S PHOTOGRAPHIC METHODS

Mrs. Cameron used the wet collodion process which had been invented by Frederick Scott-Archer in 1851. A glass plate was used instead of paper as a surface for the emulsion. The glass was free of grain and therefore gave much better definition than the textured paper negative did. Scott-Archer had found that collodion, a solution of gun cotton in alcohol, was a suitable medium for carrying the chemicals, as long as the solution, which supported the chemicals, remained wet. The plates had therefore to be prepared by the photographer on the site.

A highly polished, spotless glass plate had to be evenly coated with collodion solution and dipped into a bath of nitrate of silver to make the emulsion sensitive to light. It was then taken out, in semi-darkness, fitted into a slide, placed in the camera, exposed and then immediately developed. A knock, changes in temperature, even breathing on the glass surface might spoil the negative, which was probably twelve inches by fifteen inches, and so extremely tricky to handle. After exposure, the developing solution had to be poured over the plate. If the negative had survived thus far it had to be varnished to protect the chemical surface. This involved heating the plate and once again pouring liquid over it, with the risk that the varnish might crack the collodion surface.

Mrs. Cameron preferred to print her negatives on silver chloride sensitised paper rather than the more popular Albumen paper, which was soaked in white of egg before being sensitised, and was claimed to give better definition. She sensitised the papers herself—child's play compared to the preparation of the negative. She was an impetuous and clumsy woman, so it is amazing that she managed to handle the chemical manœuvres as successfully as she did.

For her long exposures Mrs. Cameron used daylight but to much more dramatic effect than her contemporaries. She disapproved of retouching and was not even prepared to dot out spots on the print.

PREFACE

In a letter to Sir Edward Ryan she says, "Lastly as to spots, they must, I think remain. I could have them touched out, but I am the only photographer who always issues untouched photographs and artists for this reason, amongst others, value my photographs. So Mr. Watts and Mr. Rossetti and Mr. du Maurier write me above all others."[1]

The characteristic out of focus effect is probably the result of using a lens of long focal length, which was necessary to cover the area of the plate. She would have worked with a wide open aperture at a distance of a few feet from her sitter, so there was very little depth of focus and increasing loss of definition in the outer areas of the photograph. While this could enhance the picture, there was little that Mrs. Cameron could do to prevent it, with her equipment and approach. Sitters would have to maintain their pose for three to seven minutes.

The intensity of feeling which Mrs. Cameron put into her photographic sessions made them a tremendous ordeal:

"The studio, I remember, was very untidy and very uncomfortable. Mrs. Cameron put a crown on my head and posed me as the heroic queen. This was somewhat tedious, but not half so bad as the exposure. Mrs. Cameron warned me before it commenced that it would take a long time, adding, with a sort of half groan, that it was the sole difficulty she had to contend with in working with large plates. The difficulties of development she did not seem to trouble about. The exposure began. A minute went over and I felt as if I must scream, another minute and the sensation was as if my eyes were coming out of my head; a third and the back of my neck appeared to be afflicted with palsy, a fourth, and the crown, which was too large, began to slip down my forehead; a fifth, but here I utterly broke down, for Mr. Cameron, who was very aged, and had unconquerable fits of hilarity which always came in the wrong places, began to laugh audibly, and this was too much for my self-possession, and I was obliged to join the dear old gentleman. When Mrs. Cameron with the assistance of 'Mary'— the beautiful girl who figured in so many pictures, and notably in the picture called the 'Madonna'—bore off the gigantic dark slide with the remark that she was afraid I had moved, I was obliged to tell her that I was sure I had. This first picture was nothing but a series of 'wobblings' and so was the second; the third was more successful, though the torture of standing for nearly ten minutes without a headrest was something indescribable. I have a copy of that picture now. The face and crown have not more than six outlines, and if it was Mrs. Cameron's intention to represent Senobia in the last stage of misery and desperation, I think she succeeded."[2]

[1]Quoted from *Julia Margaret Cameron, Her Life and Photographic Work* by Helmut Gernsheim (The Fountain Press, 1948).

[2]*A Reminiscence of Mrs. Cameron* by "A Lady Amateur" (Photographic News, January, 1886).

JULIA MARGARET CAMERON
By Virginia Woolf

JULIA MARGARET CAMERON, the third daughter of James Pattle of the Bengal Civil Service, was born on June 11, 1815. Her father was a gentleman of marked, but doubtful, reputation, who after living a riotous life and earning the title of "the biggest liar in India," finally drank himself to death and was consigned to a cask of rum to await shipment to England. The cask was stood outside the widow's bedroom door. In the middle of the night she heard a violent explosion, rushed out, and found her husband, having burst the lid off his coffin, bolt upright menacing her in death as he had menaced her in life. "The shock sent her off her head then and there, poor thing, and she died raving." It is the father of Miss Ethel Smyth who tells the story (*Impressions that Remained*), and he goes on to say that, after "Jim Blazes" had been nailed down again and shipped off, the sailors drank the liquor in which the body was preserved, "and, by Jove, the rum ran out and got alight and set the ship on fire! And while they were trying to extinguish the flames she ran on a rock, blew up, and drifted ashore just below Hooghly. And what do you think the sailors said? 'That Pattle had been such a scamp that the devil wouldn't let him go out of India!'"

His daughter inherited a strain of that indomitable vitality. If her father was famous for his lies, Mrs. Cameron had a gift of ardent speech and picturesque behaviour which has impressed itself upon the calm pages of Victorian biography. But it was from her mother, presumably, that she inherited her love of beauty and her distaste for the cold and formal conventions of English society. For the sensitive lady whom the sight of her husband's body had killed was a Frenchwoman by birth. She was the daughter of Chevalier Antoine de l'Étang, one of Marie Antoinette's pages, who had been with the Queen in prison till her death, and was only saved by his own youth from the guillotine. With his wife, who had been one of the Queen's ladies, he was exiled to India, and it is at Ghazipur, with the miniature that Marie Antoinette gave him laid upon his breast, that he lies buried.

But the de l'Étangs brought from France a gift of greater value than the miniature of the unhappy Queen. Old Madame de l'Étang was extremely handsome. Her daughter, Mrs. Pattle, was lovely. Six of Mrs. Pattle's seven daughters were even more lovely than she was. "Lady Eastnor is one of the handsomest women I ever saw in any country," wrote Henry Greville of the youngest, Virginia. She underwent the usual fate of early Victorian beauty: was mobbed in the streets, celebrated in odes, and even made the subject of a paper in *Punch* by Thackeray, "On

13

a good-looking lady." It did not matter that the sisters had been brought up by their French grandmother in household lore rather than in book learning. "They were artistic to their finger tips, with an appreciation—almost to be called a culte—for beauty." In India their conquests were many, and when they married and settled in England, they had the art of making round them, whether at Freshwater or at Little Holland House, a society of their own ("Pattledom" it was christened by Sir Henry Taylor), where they could drape and arrange, pull down and build up, and carry on life in a high-handed and adventurous way which painters and writers and even serious men of affairs found much to their liking. "Little Holland House, where Mr. Watts lived, seemed to me a paradise," wrote Ellen Terry, "where only beautiful things were allowed to come. All the women were graceful, and all the men were gifted." There, in the many rooms of the old Dower House, Mrs. Prinsep lodged Watts and Burne Jones, and entertained innumerable friends among lawns and trees which seemed deep in the country, though the traffic of Hyde Park Corner was only two miles distant. Whatever they did, whether in the cause of religion or of friendship, was done enthusiastically.

Was a room too dark for a friend? Mrs. Cameron would have a window built instantly to catch the sun. Was the surplice of the Rev. C. Beanlands only passably clean? Mrs. Prinsep would set up a laundry in her own house and wash the entire linen of the clergy of St. Michael's at her own expense. Then when relations interfered, and begged her to control her extravagance, she nodded her head with its coquettish white curls obediently, heaved a sigh of relief as her counsellors left her, and flew to the writing-table to despatch telegram after telegram to her sisters describing the visit. "Certainly no one could restrain the Pattles but themselves," says Lady Troubridge. Once indeed the gentle Mr. Watts was known to lose his temper. He found two little girls, the granddaughters of Mrs. Prinsep, shouting at each other with their ears stopped so that they could hear no voices but their own. Then he delivered a lecture upon self-will, the vice, he said, which they had inherited from their French ancestress, Madame de l'Étang. "You will grow up imperious women," he told them, "if you are not careful." Had they not into the bargain an ancestor who blew the lid off his coffin?

Certainly Julia Margaret Cameron had grown up an imperious woman; but she was without her sisters' beauty. In the trio where, as they said, Lady Somers was Beauty, and Mrs. Prinsep Dash, Mrs. Cameron was undoubtedly Talent.

"She seemed in herself to epitomize all the qualities of a remarkable family," wrote Mrs. Watts, "presenting them in a doubly distilled form. She doubled the generosity of the most generous of the sisters, and the impulsiveness of the most impulsive. If they were enthusiastic, she was so twice over; if they were persuasive,

she was invincible. She had remarkably fine eyes, that flashed like her sayings, and grew soft and tender if she was moved. . . ." But to a child[1] she was a terrifying apparition "short and squat, with none of the Pattle grace and beauty about her, though more than her share of their passionate energy and wilfulness. Dressed in dark clothes, stained with chemicals from her photography (and smelling of them too), with a plump eager face and a voice husky, and a little harsh, yet in some way compelling and even charming," she dashed out of the studio at Dimbola, attached heavy swans' wings to the children's shoulders, and bade them "Stand there" and play the part of the Angels of the Nativity leaning over the ramparts of Heaven.

But the photography and the swans' wings were still in the far future. For many years her energy and her creative powers poured themselves into family life and social duties. She had married, in 1838, a very distinguished man, Charles Hay Cameron, "a Benthamite jurist and philosopher of great learning and ability," who held the place, previously filled by Lord Macaulay, of fourth Member of Council at Calcutta. In the absence of the Governor-General's wife, Mrs. Cameron was at the head of European society in India, and it was this, in Sir Henry Taylor's opinion, that encouraged her in her contempt for the ways of the world when they returned to England. She had little respect, at any rate, for the conventions of Putney. She called her butler peremptorily "Man." Dressed in robes of flowing red velvet, she walked with her friends, stirring a cup of tea as she walked, half-way to the railway station in hot summer weather. There was no eccentricity that she would not have dared on their behalf, no sacrifice that she would not have made to procure a few more minutes of their society. Sir Henry and Lady Taylor suffered the extreme fury of her affection. Indian shawls, turquoise bracelets, inlaid portfolios, ivory elephants, "etc.," showered on their heads. She lavished upon them letters six sheets long "all about ourselves." Rebuffed for a moment, "she told Alice [Lady Taylor] that before the year was out she would love her like a sister," and before the year was out Lady Taylor could hardly imagine what life had been without Mrs. Cameron. The Taylors loved her; Aubrey de Vere loved her; Lady Monteagle loved her; and "even Lord Monteagle, who likes eccentricity in no other form, likes her." It was impossible, they found, not to love that "genial, ardent, and generous" woman, who had "a power of loving which I have never seen exceeded, and an equal determination to be loved." If it was impossible to reject her affection, it was even dangerous to reject her shawls. Either she would burn them, she threatened, then and there, or, if the gift were returned, she would sell it, buy with the proceeds a very expensive invalid sofa, and present it to the Putney Hospital for Incurables with an inscription which said, much to the surprise of Lady Taylor, when she chanced upon it, that it

[1]*Memories and Reflections* by Lady Troubridge, p. 34.

15

was the gift of Lady Taylor herself. It was better, on the whole, to bow the shoulder and submit to the shawl.

Meanwhile she was seeking some more permanent expression of her abundant energies in literature. She translated from the German, wrote poetry, and finished enough of a novel to make Sir Henry Taylor very nervous lest he should be called upon to read the whole of it. Volume after volume was despatched through the penny post. She wrote letters till the postman left, and then she began her postscripts. She sent the gardener after the postman, the gardener's boy after the gardener, the donkey galloping all the way to Yarmouth after the gardener's boy. Sitting at Wandsworth Station she wrote page after page to Alfred Tennyson until "as I was folding your letter came the screams of the train, and then the yells of the porters with the threat that the train would not wait for me," so that she had to thrust the document into strange hands and run down the steps. Every day she wrote to Henry Taylor, and every day he answered her.

Very little remains of this enormous daily volubility. The Victorian age killed the art of letter writing by kindness: it was only too easy to catch the post. A lady sitting down at her desk a hundred years before had not only certain ideals of logic and restraint before her, but the knowledge that a letter which cost so much money to send and excited so much interest to receive was worth time and trouble. With Ruskin and Carlyle in power, a penny post to stimulate, a gardener, a gardener's boy, and a galloping donkey to catch up the overflow of inspiration, restraint was unnecessary and emotion more to a lady's credit, perhaps, than common sense. Thus to dip into the private letters of the Victorian age is to be immersed in the joys and sorrows of enormous families, to share their whooping coughs and colds and misadventures, day by day, indeed hour by hour. The standard of family affection was very high. Illness elicited showers of enquiries and kindnesses. The weather was watched anxiously to see whether Richard would be wet at Cheltenham, or Jane catch cold at Broadstairs. Grave misdemeanours on the part of governesses, cooks, and doctors ("he is guilty of culpable carelessness, profound ignorance," Mrs. Cameron would say of the family physician), were detailed profusely, and the least departure from family morality was vigilantly pounced upon and volubly imparted.

Mrs. Carmeron's letters were formed upon this model; she counselled and exhorted and enquired after the health of dearest Emily with the best; but her correspondents were often men of exalted genius to whom she could express the more romantic side of her nature. To Tennyson she dwelt upon the beauty of Mrs. Hambro, "frolicsome and graceful as a kitten and having the form and eye of an antelope. . . . Then her complexion (or rather her skin) is faultless—it is like the leaf of 'that consummate flower' the Magnolia—a flower which is, I think, so

16

mysterious in its beauty as if it were the only thing left unsoiled and unspoiled from the garden of Eden. . . . We had a standard Magnolia tree in our garden at Sheen, and on a still summer night the moon would beam down upon those ripe rich vases, and they used to send forth a scent which made the soul faint with a sense of the luxury of the world of flowers.'' From such sentences it is easy to see why Sir Henry Taylor looked forward to reading her novel with dread. "Her genius (of which she has a great deal) is too profuse and redundant, not distinguishing between felicitous and infelicitous," he wrote. "She lives upon superlatives as upon her daily bread."

But the zenith of Mrs. Cameron's career was at hand. In 1860 the Camerons bought two or three rose-covered cottages at Freshwater, ran them together, and supplemented them with outhouses to receive the overflow of their hospitality. For at Dimbola—the name was taken from Mr. Cameron's estate in Ceylon—everybody was welcome. "Conventionalities had no place in it." Mrs. Cameron would invite a family met on the steamer to lunch without asking their names, would ask a hatless tourist met on the cliff to come in and choose himself a hat, would adopt an Irish beggar woman and send her child to school with her own children. "What will become of her?" Henry Taylor asked, but comforted himself with the reflection that though Julia Cameron and her sisters "have more of hope than of reason," still "the humanities are stronger in them than the sentimentalities," and they generally brought their eccentric undertakings to a successful end. In fact the Irish beggar child grew up into a beautiful woman, became Mrs. Cameron's parlour-maid, sat for her portrait, was sought in marriage by a rich man's son, filled the position with dignity and competence, and in 1878 enjoyed an income of two thousand four hundred pounds a year. Gradually the cottages took colour and shape under Mrs. Cameron's hands. A little theatre was built where the young people acted. On fine nights they trapesed up to the Tennysons and danced; if it were stormy, and Mrs. Cameron preferred the storm to the calm, she paced the beach and sent for Tennyson to come and pace by her side. The colour of the clothes she wore, the glitter and hospitality of the household she ruled reminded visitors of the East. But if there was an element of "feudal familiarity," there was also a sense of "feudal discipline." Mrs. Cameron was extremely outspoken. She could be highly despotic. "If ever you fall into temptation," she said to a cousin, "down on your knees and think of Aunt Julia." She was caustic and candid of tongue. She chased Tennyson into his tower vociferating "Coward! Coward!" and thus forced him to be vaccinated. She had her hates as well as her loves, and alternated in spirits "between the seventh heaven and the bottomless pit." There were visitors who found her company agitating, so odd and bold were her methods of conversation, while the variety and brilliance of the society she collected round her caused a certain "poor Miss Stephen" to lament:

17

"Is there *nobody* commonplace?" as she saw Jowett's four young men drinking brandy and water, heard Tennyson reciting 'Maud,' while Mr. Cameron wearing a coned hat, a veil, and several coats paced the lawn which his wife in a fit of enthusiasm had created during the night.

In 1865, when she was fifty, her son's gift of a camera gave her at last an outlet for the energies which she had dissipated in poetry and fiction and doing up houses and concocting curries and entertaining her friends. Now she became a photographer. All her sensibility was expressed, and, what was perhaps more to the purpose, controlled in the new born art. The coal-house was turned into a dark room; the fowl-house was turned into a glass-house. Boatmen were turned into King Arthur; village girls into Queen Guenevere. Tennyson was wrapped in rugs: Sir Henry Taylor was crowned with tinsel. The parlour-maid sat for her portrait and the guest had to answer the bell. "I worked fruitlessly but not hopelessly," Mrs. Cameron wrote of this time. Indeed, she was indefatigable. "She used to say that in her photography a hundred negatives were destroyed before she achieved one good result; her object being to overcome realism by diminishing just in the least degree the precision of the focus." Like a tigress where her children were concerned, she was as magnificently uncompromising about her art. Brown stains appeared on her hands, and the smell of chemicals mixed with the scent of the sweet briar in the road outside her house. She cared nothing for the miseries of her sitters nor for their rank. The carpenter and the Crown Prince of Prussia alike must sit as still as stones in the attitudes she chose, in the draperies she arranged, for as long as she wished. She cared nothing for her own labours and failures and exhaustion. "I longed to arrest all the beauty that came before me, and at length the longing was satisfied," she wrote. Painters praised her art; writers marvelled at the character her portraits revealed. She herself blazed up at length into satisfaction with her own creations. "It is a sacred blessing which has attended my photography," she wrote. "It gives pleasure to millions." She lavished her photographs upon her friends and relations, hung them in railway waiting-rooms, and offered them, it is said, to porters in default of small change.

Old Mr. Cameron meanwhile retired more and more frequently to the comparative privacy of his bedroom. He had no taste for society himself, but endured it, as he endured all his wife's vagaries, with philosophy and affection. "Julia is slicing up Ceylon," he would say, when she embarked on another adventure or extravagance. Her hospitalities and the failure of the coffee crop ("Charles speaks to me of the flower of the coffee plant. I tell him that the eyes of the first grandchild should be more beautiful than any flowers," she said) had brought his affairs into a precarious state. But it was not business anxieties alone that made Mr. Cameron wish to visit Ceylon. The old philosopher became more and more obsessed with the desire

to return to the East. There was peace; there was warmth; there were the monkeys and the elephants whom he had once lived among "as a friend and a brother." Suddenly, for the secret had been kept from their friends, the Camerons announced that they were going to visit their sons in Ceylon. Their preparations were made and friends went to say good-bye to them at Southampton. Two coffins preceded them on board packed with glass and china, in case coffins should be unprocurable in the East; the old philosopher with his bright fixed eyes and his beard "dipt in moonlight" held in one hand his ivory staff and in the other Lady Tennyson's parting gift of a pink rose; while Mrs. Cameron, "grave and valiant," vociferated her final injunctions and controlled not only innumerable packages but a cow.

They reached Ceylon safely, and in her gratitude Mrs. Cameron raised a subscription to present the Captain with a harmonium. Their house at Kalutara was so surrounded by trees that rabbits and squirrels and minah birds passed in and out while a beautiful tame stag kept guard at the open door. Marianne North, the traveller, visited them there and found old Mr. Cameron in a state of perfect happiness, reciting poetry, walking up and down the verandah, with his long white hair flowing over his shoulders, and his ivory staff held in his hand. Within doors Mrs. Cameron still photographed. The walls were covered with magnificent pictures which tumbled over the tables and chairs and mixed in picturesque confusion with books and draperies. Mrs. Cameron at once made up her mind that she would photograph her visitor and for three days was in a fever of excitement. "She made me stand with spiky coconut branches running into my head . . . and told me to look perfectly natural," Miss North remarked. The same methods and ideals ruled in Ceylon that had once ruled in Freshwater. A gardener was kept, though there was no garden and the man had never heard of the existence of such a thing, for the excellent reason that Mrs. Cameron thought his back "absolutely superb." And when Miss North incautiously admired a wonderful grass green shawl that Mrs. Cameron was wearing, she seized a pair of scissors, and saying: "Yes, that would just suit you," cut it in half from corner to corner and made her share it. At length, it was time for Miss North to go. But still Mrs. Cameron could not bear that her friends should leave her. As at Putney she had gone with them stirring her tea as she walked, so now at Kalutara she and her whole household must escort her guest down the hill to wait for the coach at midnight. Two years later (in 1879) she died. The birds were fluttering in and out of the open door; the photographs were tumbling over the tables; and, lying before a large open window Mrs. Cameron saw the stars shining, breathed the one word "Beautiful," and so died.

Editor's Note

Some corrections are needed to Virginia Woolf's dramatic account of the departure of Mrs. Cameron's father from India, which was based on Ethel Smyth's *Impressions that Remained*. These impressions were not always strictly accurate. There is no reliable evidence to suggest that James Pattle, who held responsible posts on the financial and judicial side of the Bengal Civil Service, drank more than his contemporaries. Ethel Smyth was probably confusing him with his brother Colonel Pattle, who had the reputation of being wild and untruthful. James Pattle's body was brought back to England and is buried at St. Giles' Church, Camberwell. His wife did not die insane. She had very bad health for some years and died on board ship on the voyage to England.

The Chevalier de l'Étang was banished by the King *before* the Revolution, when he was an officer of the King's bodyguard and superintendent of the Royal Stud—he had written a book on horse management for the French Army.

Mme. de l'Étang was *not* "one of the Queen's ladies." She was born in Pondicherry, India, the daughter of the Captain of the Port, and she did not go to France until she took her grand-daughter there to be educated, probably in the 1820s.

It is worth looking at the ramifications of the Pattle family, because many of them figure in Mrs. Cameron's photographs. The seven surviving daughters of James and Adeline Pattle were: Adeline (1812–1836) who married Colin MacKenzie (later General); Julia Margaret (1815–1879) who married Charles Hay Cameron, a jurist responsible for the codification of the Indian legal system; Sarah (1816–1887) who married Henry Thoby Prinsep, an official in the East India Company; Maria (1818–1892) who married Dr. John Jackson; Louisa (1821–1873) who married H. V. Bayley; Virginia (1827–1910) who married Lord Eastnor (later Earl Somers); Sophia (1829–1911) who married Sir John Dalrymple.

Sarah Prinsep's daughter Alice married Charles Gurney and had two daughters, Laura and Rachel. Laura (Queenie) married Sir Thomas Troubridge and Rachel the Earl of Dudley. Laura Troubridge had a son, Ernest, who married Una Taylor, who later married John Radcliffe Hall and wrote *The Well of Loneliness*.

Maria Jackson had three daughters, Adeline, who married Henry Halford Vaughan, Mary who married Herbert Fisher, and Julia, who married first Herbert Duckworth and second Leslie Stephen. Herbert Fisher was tutor to the Prince of Wales (later Edward VII) and father of H. A. L. Fisher the historian, and Florence, the wife of F. W. Maitland. The two daughters of Julia's marriage to Sir Leslie Stephen, the philosopher and creator of the Dictionary of National Biography, were Vanessa, later the wife of Clive Bell, and Virginia, who became the wife of Leonard Woolf; the two sons were Thoby and Adrian Stephen.

The Tennyson family were close friends with the Camerons, and May Prinsep, Sarah and Henry Thoby Prinsep's niece, married Hallam, Lord Tennyson, as his

EDITOR'S NOTE

second wife. Besides her famous studies of the poet, Mrs. Cameron also photographed his brother Horatio and his sons, Hallam and Lionel.

Of Mrs. Cameron's children, only her daughter Julia, who married Charles Lloyd Norman, D.L., J.P., and her eldest son Eugene, who married Caroline Browne, left any descendants beyond the first generation. In fact only one other of her five sons, Ewen, married. He left a son and a daughter, both of whom died childless.

ACKNOWLEDGEMENTS

The publishers are grateful to the following for permission to reproduce photographs by Julia Margaret Cameron:

George Clive for Plates 27–29
Mrs. David Garnett for Plates 30, 31, 32 and 35
Major-General C. W. Norman for Plates 9, 13, 14, 19, 23, 25, 26, 34 and 36–44
The Victoria and Albert Museum for Plate 33

MRS. CAMERON'S PHOTOGRAPHS

By Roger Fry

THE POSITION of photography is uncertain and uncomfortable. No one denies its immense services of all kinds, but its status as an independent art has always been disputed. It has never managed to get its Muse or any proper representation on Parnassus, and yet it will not give up its pretentions altogether. Mrs. Cameron's photographs posed the question long ago, but it was shelved. The present publication affords perhaps a favourable opportunity to reopen the discussion.

But before we consider the abstract aesthetic problem, it will be as well to look at some of her plates and find out what it is that she has handed on to posterity. To begin with, surely the most fascinating record of a period. I doubt if any period in all history has been transmitted as this of England of the 60's and 70's of last century is through Mrs. Cameron's plates. A number of things contribute to decide whether a period can be transmitted or not. Much depends on the current attitude at any given moment of men to their own personality. In the Renaissance men were much too proud of being whatever odd thing heredity, fate, and circumstance had happened to make them, to wish from the portraitist but the most literal and complete truth he could give. At other periods, the seventeenth century, for instance, men were, for some reason or other, more anxious to insist on the fact that they conformed to the type of the day. They insisted that the artist should, so far as possible, squeeze them into conformity with that. The same is true of the present moment, when, though the fashionable portraits, photographed or otherwise, are as like as peas to one another, they are not like any individual human being at all.

Now it so happens that in the 60's and 70's England was enjoying a spell of strong individualism. People were indeed excessively careful to conform to a certain code of morals, but within the limits of that they were not afraid of their own personalities.

That, then, was a favouring condition, and it coincided with the spread of photography and the appearance of Mrs. Cameron.

And in this matter of the transmission of a period, photography is of immense importance. Not but what van Eyck and Ghirlandajo were able to transmit much to us, only whenever an artist attains to the power of realizing the human face with anything like the same completeness as the photograph does he is almost certain to be so great an artist as to stand between us and his sitters. Rembrandt, for instance, is so infinitely more important to us than any of his sitters, himself included, that we

pass at once into the universal and dateless world which his imagination created for us. We get much nearer to seventeenth-century Holland in Terborgh or Metsu than in Rembrandt.

So photography, at least in Mrs. Cameron's hands, can give us something that only the greatest masters were capable of giving, and they, as we see, were always occupied in giving us so much more that we cannot bother about this.

The England that Mrs. Cameron reveals then was a vigorously individualistic England. It was also given over to art to an extent which we find it hard to understand. Pre-Raphaelitism had leavened the cultured society of the day with an extraordinary passion for beauty. The notion of beauty which obtained had in it always a streak of affectation, it was ensued with a tremendous self-conscious determination. The cult of beauty was a religion and a highly Protestant one, a violent and queasy aversion from the jocular vulgarity of Philistinism. The devotees of this creed cultivated the exotic and precious with all the energy and determination of a dominant class. With the admirable self-assurance which this position gave them they defied ribaldy and flouted common sense. They had the courage of their affectations; they openly admitted to being "intense." In PLATE 22 we get a picture of this strange world. There is something touching and heroic about the naïve confidence of these people. They are so unconscious of the abyss of ridicule which they skirt, so determined, so conscientious, so bravely provincial. It was perhaps a moment when the provincialism of English culture was almost justified by the concentrated effort which it made towards creation, even if the results that emerged now seem to us scarcely adequate. Certainly this 'Rosebud Garden of Girls,' as Mrs. Cameron so bravely entitled her plate, revives for us a wonderfully remote and strange social situation. We realize something of the solemn ritual which surrounded these beautiful women. How natural it seems to them to make up and pose like this. They have been so fashioned by the art of the day that to be themselves part of a picture is almost an instinctive function.

Yes, beauty was a serious matter to Mrs. Cameron and her beautiful sitters. But life was altogether serious and earnest, as Longfellow assured them. In that walled-in garden of solid respectability, sheltered by its rigid sexual morality from the storms of passion and by its secluded elevation from the shafts of ridicule, that pervading seriousness provided an atmosphere wherein great men could be grown to perfection—or rather in which men of distinction could be forced into great men. Look at Longfellow himself, for instance; in that world there is not a doubt but that he was a great man. And what chances would he have to-day? No one of Longfellow's calibre could ever grow to such dimensions or carry himself thus.

In that protected garden of culture women grew to strange beauty, and the

men—how lush and rank are their growths! How they abound in the sense of their own personalities! There is Sir Joseph Hooker, a learned and celebrated botanist, but no earth-shaking genius—how superbly he has sprouted in that mild and humid air. Then there was no need to grow defences, no apologies were expected, no deprecating ironies; these men could safely flaunt all their idiosyncrasies on one condition only, that of staying within the magic circle of conventional morality. Browning alone seems to take no advantage of the situation. Was it a deeper sense of life, a knowledge of character which went behind the façades and undermined his own security? He is the least naïve of all. But the Poet Laureate flames out all the more, by comparison, with his too ambrosial locks. How he basks in the genial warmth.

It is curious to note how much the writers and artists are on show. How anxious they are to keep it up to the required pitch. (The numerous photographs of Sir Henry Taylor, which have had to be omitted from the present series, are incredibly diverting in this respect.) And, by comparison, see the supreme unselfconsciousness and simplicity of the men of science: the Herschel, the Darwin, the Hooker—what a pity Huxley is not here. These men alone possessed an unwavering faith which looked for no external support nor approval.

But the women, one may surmise, were more interested in the art which moulded and celebrated them, and Mrs. Cameron was pre-eminently an artist. To return, therefore, to the 'Rosebud Garden of Girls.' It is definitely a pre-Raphaelite picture, and it is by no means the worst of them. It breaks down here and there it is true. The mass of white of the foremost figure is lacking in shape and definition. It is vague in movement and too unbroken for the rest of the design. The greenery and flowers in the background have come out too tight and minute as compared with the heads which seem to me almost perfect. But, on the whole, how successful a composition it is. It is, however, almost the only case of a group which has come near to artistic success. The albums which Mrs. Cameron has left contain many attempts to rival the poetical and allegorical compositions which were then in vogue. Watts seems to have been the chief inspiration. We have several 'Annunciations' and 'Holy Families,' 'The Kiss of Peace,' 'Venus Removing Cupid's Wings,' a comparatively harmless operation, for the wings never seem to have adhered very securely—two companion pictures of winged cherubim entitled ' I Wait' and 'I Come.' Then in the Tennysonian vein 'Œnone' and 'Enoch Arden,' and, descending to the more pedestrian genre of Maddox Brown, 'Blackberry Gathering.' All these are elaborately arranged and carefully thought-out group compositions but, mediocre as the pictures were which Mrs. Cameron sought to rival, it must be admitted that they suffer nothing by the comparison. With the exception of the group reproduced on PLATE 22, these must all be judged as failures from an aesthetic standpoint.

We here touch on one of the most definite limitations of photography used as an art. The chances are too much against success where a complex of many volumes is involved. The co-ordination necessary to aesthetic unity is, of course, only an accident in nature, and while that accident may occur in a single volume such as a human head, which has its own internal principle of harmony, the chances are immensely against such co-ordination holding for any considerable sequences of volumes, and although the control of the photographic artist may extend to certain things such as the disposition of draperies, he is bound on the whole to depend upon the fortunate accidents of the natural kaleidoscope.

Thus it comes about that we must turn to the portraits to get an idea of how considerable an artist Mrs. Cameron was. For let there be no mistake about it, the unique record of a whole period which these plates comprise is not due merely to the fact of the existence of the camera, it is far more due to the eye of the artist who directed and focussed it. And Mrs. Cameron had a wonderful perception of character as it is expressed in form, and of form as it is revealed or hidden by the incidence of light. Take, for example, the Carlyle [PLATE 10]. Neither Whistler nor Watts come near to this in the breadth of the conception, in the logic of the plastic evocations, and neither approach the poignancy of this revelation of character. And this master-piece is accomplished by a patient use of all the accidents and conditions of Mrs. Cameron's medium. For the process she employed was far removed from those of modern photography. The wet plates used on this scale needed, I believe, extra-ordinarily skilful manipulation and demanded a lengthy exposure. Besides this there were probably imperfections in the lens as compared with modern products. But it was by an exact sense of how to make use of all these accidents that these astonishing results were secured. It may even be that the long exposure, though I believe it meant destroying far more plates than were kept, was, on happy occasions, actually profitable. The slight movements of the sitter gave a certain breadth and envelop-ment to the form and prevented those too instantaneous expressions which in modern photography so often have an air of caricature. Both expression and form were slightly generalized; they had not that too acute, too positive quality from which modern photography generally suffers.

As an example of the almost complete success possible where a simple volume is taken for the motive we may consider the 'Mary Mother' [PLATE 18]. Here the artist has been able to control everything, the *mise-en-page*, the disposition of the drapery, and the illumination; and the result is almost perfect. No doubt a great painter accepting the data of this would introduce almost unconsciously certain changes. The rhythm of the drapery would have been more completely brought out by slight amplifications here and retrenchments there, by a greater variety and

consistency of accents, and by certain obliterations. In particular the awkward direction of the fold seen in the penumbra behind the profile would have been suppressed or changed, and certain curious accidents in the lighted and shaded portions of the lips would have been modified, but none the less few could have surpassed the beauty of modelling of the left-hand side of the face or the exquisite perfection of the contour to the right.

As proof of Mrs. Cameron's right judgment and delicate sensibility and of her fertility of invention examine PLATE 17. How perfectly the diffused and indefinite illumination is suited to bring out all that was significant in the subtle relief of the child's features and the unanalysable rhythm of the oval of her mask. The photograph of Mrs. Herbert Duckworth [PLATE 16], is a splendid success. The transitions of tone in the cheek and the delicate suggestions of reflected light, no less than the beautiful "drawing" of the profile, are perfectly satisfying.

To return to the men's portraits—both the Herschels [PLATES 1 and 2] seem to me indisputable creations, perfectly distinct, and each the result of an original and definite idea or interpretation of the given data.

Before such works it is impossible to refuse to Mrs. Cameron the title of artist. One cannot doubt that photography's claim to the status of an art would never have been doubted if it had not been that so few artists have ever used the medium. So far as I know Mrs. Cameron still remains far and away the most distinguished.

In this matter our judgments tend to be affected by a widely held idea of some intimate connexion between manual dexterity and artistic power. It requires an effort to shake off altogether the notion that virtuosity is a virtue. The admiring envy and wonder which we feel before an accomplished performance too frequently colours or even determines our admiration of the artist. We forget that an attitude which is perfectly justified before a juggler or an acrobat is entirely irrelevant before an artist. In this connexion Amaury Duval tells a story about Ingres which is significant. No one had a greater right than Ingres, had he chosen to do so, to pride himself on his wonderful virtuosity as a draughtsman. That he valued it as a means to an end is certain, for he used to say to his pupils: "If you have a hundred pounds worth of skill it is always worth while to buy another halfpennyworth, but" he added, "you must never show it." The story is to the effect that when Paganini came to perform in Paris Ingres took Duval to hear him. In his early days in Rome he used to play the violin with Paganini, and he described to his pupil how great a musician Paganini was, how profound his understanding of the great masters. But many years had elapsed and in the interval Paganini had developed his astonishing powers as a virtuoso, but had also yielded to the seduction of exploiting them. When the first notes were struck Ingres was in ecstasy at the beauty of the tone, but little by little

27

as Paganini began to display his skill at the expense of expression, Ingres' face became more and more clouded, he began to drum with his fingers on the front of the box, and finally he growled out "Le traître" and hurriedly left the theatre.

The importance usually attributed to manual skill in pictorial art has, I think, prevented hitherto a fair discussion of the position of photography as a possible branch of visual art. We have a natural tendency to put aside any work in which mechanism replaces that nervous control of the hand which alone seems capable of transmitting the artist's feeling to us. We are, I think, quite right to esteem this quality of works of art very highly, but we are wrong to consider it a *sine quâ non* of all artistic expression. With the inevitable growth of mechanical processes in the modern world we shall probably become increasingly able to concentrate our attention on those elements of artistic expression which do not depend upon this intimate contact at every point of the work with the artist's nervous control, and to disregard those particular qualities in the work which depend exclusively on that. Other qualities undoubtedly remain, such, for instance, as the general organization of the forms within a given rectangle, the balance of movements throughout the whole structure, the incidence, intensity, and quality of the light. In short, all those elements of a picture which we may sum up in the word composition are to some extent independent of the exact quality of the texture at each point.

In any case, Mrs. Cameron's photographs already bid fair to outlive most of the works of the artists who were her contemporaries. One day we may hope that the National Portrait Gallery will be deprived of so large a part of its grant that it will turn to fostering the art of photography and will rely on its results for its records instead of buying acres of canvas covered at great expense by fashionable practitioners in paint.

NOTES ON THE PLATES

1 *Sir J. F. W. Herschel* (1792–1871)

The son of Sir William Herschel, the Astronomer Royal, and himself a distinguished astronomer. He is credited with inventing the terms "negative" and "positive." He also developed the use of "hypo."

3 *Henry W. Longfellow* (1807–1882)

The American poet was taken to Mrs. Cameron's studio by Tennyson in 1868. "Longfellow, you will have to do whatever she tells you. I'll come back soon and see what is left of you."

4 *Alfred Tennyson* (1809–1902)

It was William Allingham[1] who said to Tennyson "They ought to let you go free as a poet." Tennyson said "They charge me double! And I can't go anonymous," turning to Mrs. Cameron, "by reason of your confounded photographs." Allingham also describes tea with Mrs. Cameron and two of her boys: "Tennyson appeared and Mrs. Cameron showed a small firework toy called 'Pharaoh's serpents,' a kind of pastille, which, when lighted, twists about in a wormlike shape. Mrs. C. said they were poisonous and forbade us all to touch. T. in defiance put out his hand. 'Don't touch 'em!' shrieked Mrs. C. 'You shan't Alfred.' But Alfred did. 'Wash your hands then!' But Alfred wouldn't and rubbed his moustache instead, enjoying Mrs. C's. agonies. Then she said to him 'Will you come tomorrow and be photographed?' He, very emphatically, 'No' . . ." One of Tennyson's complaints was that Mrs. Cameron made bags under his eyes.

5 *Robert Browning* (1812–1889)

The poet was trapped by Mrs. Cameron in the garden at Little Holland House, and, as described in *Memorials of Edward Burne-Jones*, he was "beguiled into sitting as she would have him, draped in strange wise, and left by her helpless in the folds of the drapery, forgotten for the time as she flew on to some other conquest."

6 *G. F. Watts* (1817–1904)

Painter. He first met Mrs. Cameron at the Prinseps' house, 9 Chesterfield Street, before they moved to Little Holland House. He was a great admirer of the photographer. "Quite divine," he wrote under one photograph, and "I wish I could paint such a picture as this," under another. Mrs. Cameron drew great support from Watts' encouragement and criticism. He encouraged her to aim for strong, simple effects in her portraits. Watts lived in Little Holland House with the Prinseps and later built a house at Freshwater, so he had plenty of opportunity

[1] *Diary* (Macmillan, 1917).

to influence Mrs. Cameron, perhaps not always for the best on the artistic allegorical side, which Mrs. Cameron, unfortunately, devoted herself to as she became more famous.

7 *Joseph Joachim* (1831–1907)
Hungarian violinist and composer. He played in public at the age of seven, studied in Vienna and Leipzig where he was helped by Mendelssohn. He was acclaimed in London in 1844. His most important composition was the Hungarian Concerto.

8 *Professor Jowett* (1817–1893)
Master of Balliol College and Regius Professor of Greek at the University of Oxford.

9 *Charles Darwin* (1809–1882)
Naturalist. He wrote on some copies "I like this photograph much better than any other which has been taken of me." Darwin's work on the *Descent of Man* had been interrupted by illness in 1868, and he had come to Freshwater to recuperate. When he left the Isle of Wight Mrs. Cameron loaded him with photographs, and his son Erasmus called after her, "Mrs. Cameron, there are six people in this house all in love with you."

10 *Thomas Carlyle* (1795–1881)
Essayist and historian. He wrote to Mrs. Cameron, "Face has something of likeness, though terrifically ugly and woebegone. Chelsea June 9th 1867."

11 *Joseph D. Hooker* (1817–1911)
Botanist and traveller. Darwin confided in Hooker his discovery of natural selection—"I think I have found out the simple way by which species become exquisitely adapted to various ends."[1] He was director of the gardens at Kew from 1865 to 1885. Author of, among other books, *The Student's Flora of the British Isles*.

12 *Sir Henry Taylor* (1800–1886)
The author of *Philip van Artevelde*, which was staged by Macready in 1847 and withdrawn after six nights. Sir Henry Taylor had been working on the play for six years. He was Mrs. Cameron's most long-suffering model. "The friend of 38 years and the godfather of my child," was how she described him. She took many photographs of him, posing (sometimes with the poker) for "kings, princes, prelates, potentates and peers."

[1] *Life and Letters*, Volume III (Murray, 1887).

NOTES ON THE PLATES

NOTES ON THE PLATES

30 *Mrs. Duckworth at Saxonbury*—1872

Mrs. Herbert Duckworth with G. H. Duckworth on her knee, Florence Fisher on the left, H. A. L. Fisher on the right.

31 *Laura and Rachel Gurney*

The daughters of Charles Gurney, who was married to Alice Prinsep, Mrs. Cameron's niece. Laura married Sir Thomas Troubridge and Rachel the Earl of Dudley.

32 *Death of Elaine*

The series of photographic illustrations to *Idylls of the King* had been instigated by Tennyson. He was pleased with the end result and so was Mrs. Cameron. "It is immortality for me to be bound up with you Alfred", she wrote. In fact, her narrative photographs have the fatal flavour of amateur dramatics. The model on the left is her husband Charles Hay Cameron, who often could not restrain his laughter during the photographic sessions.

33 *Pray God Bring Father Safely Home*

The photograph was taken in a local fisherman's cottage *c.* 1872, and illustrates the sentiments of Charles Kingsley's poem *The Three Fishers*.

> *Three fishers went sailing away to the west,*
> *Away to the west as the sun went down;*
> *Each thought on the woman who loved him the best,*
> *And the children stood watching them out of the town;*
> *For men must work, and women must weep,*
> *And there's little to earn and many to keep,*
> *Though the harbour bar be moaning.*

34 *Captain Speedy, Prince Alamayu of Abyssinia and Casa the Servant,* 1868

After the death of the Emperor Theodore of Abyssinia at the Siege of Magdale, Queen Victoria invited Prince Alamayu to stay at Osborne on the Isle of Wight, where he was introduced to Tennyson, through whom Mrs. Cameron arranged to photograph him. The prince was in a highly nervous state and would only sleep in the arms of his guardian Capt. (Tristram) Speedy. William Allingham met Prince Alamayu several times. "Little Alamayu (means 'I have seen the world'), Theodore's son is here at Freshwater, in Speedy's charge, by the Queen's wish. The little prince has a native attendant, a young man, who is devoted to him. Speedy the other day overheard them amusing themselves by mimicking English people. Attendant comes up in the character of an English lady, shakes hand—'How do do?' Alamayu replies—'How you do?' Attendant—'How you like this country?' Little Prince—'Very much.' Attendant—'Ah you like very much'. —and so on."

VICTORIAN PHOTOGRAPHS

PLATE 1

SIR JOHN FREDERICK WILLIAM HERSCHEL
(1792–1871)

"Taken at his own residence Collingwood 1869. The friend of 33 years of my life. My great teacher in this art since he used to correspond with me when in India and send home all specimens of the advance of the science."

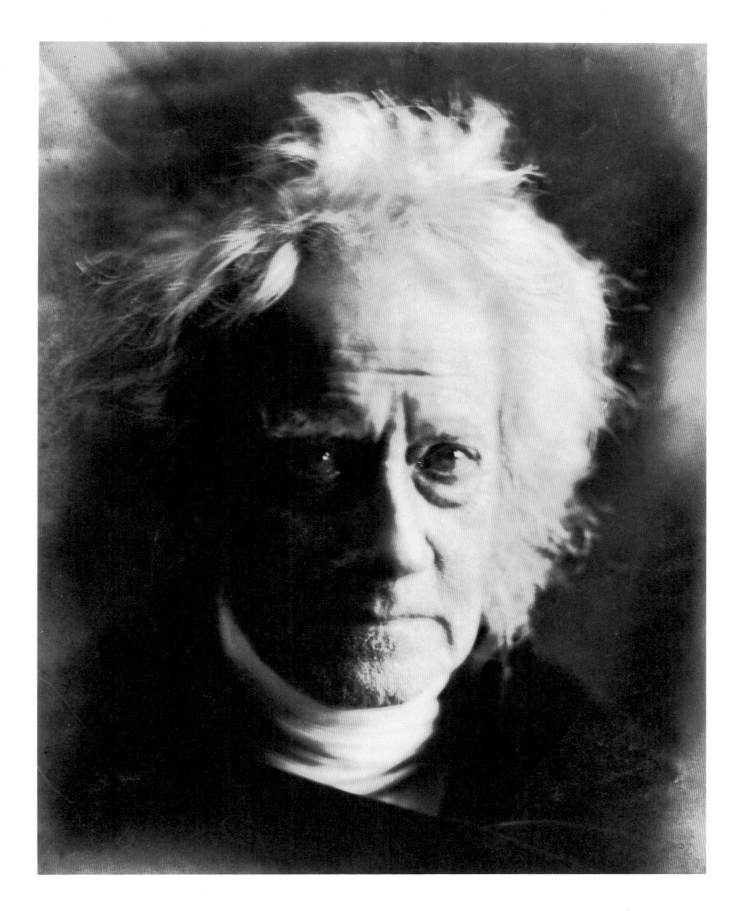

72,004

PLATE 2

SIR JOHN FREDERICK WILLIAM HERSCHEL
(April 1869)

"My revered, beloved friend wrote of this portrait that
it was the finest he had ever beheld, that it beat hollow
everything he had ever seen in photographic art."

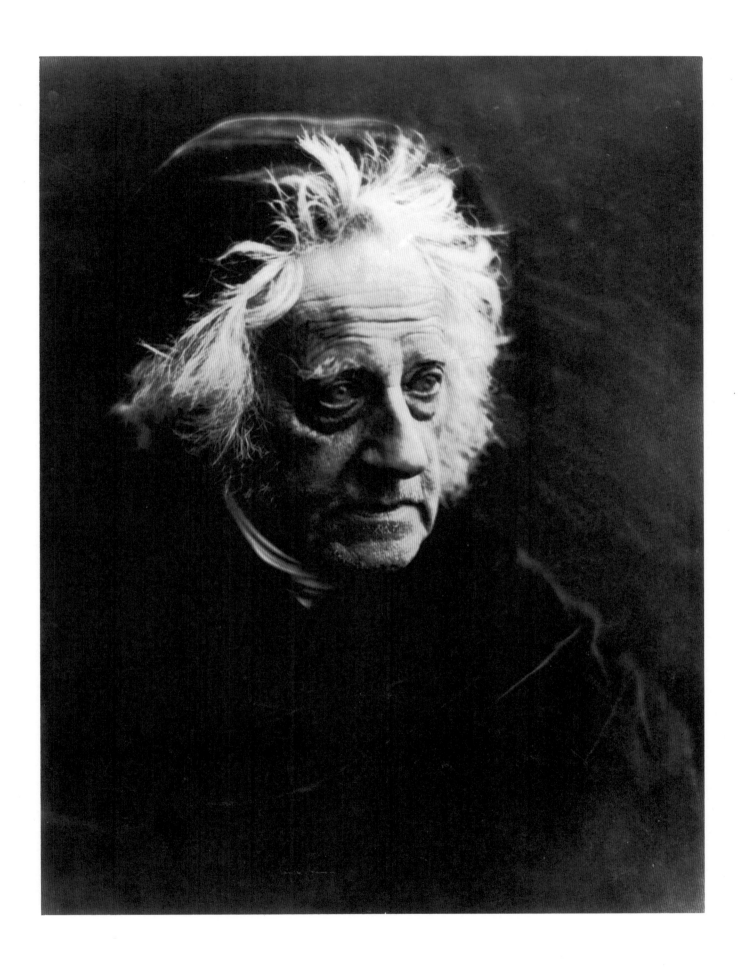

PLATE 3

HENRY WADSWORTH LONGFELLOW
(1807–1871)

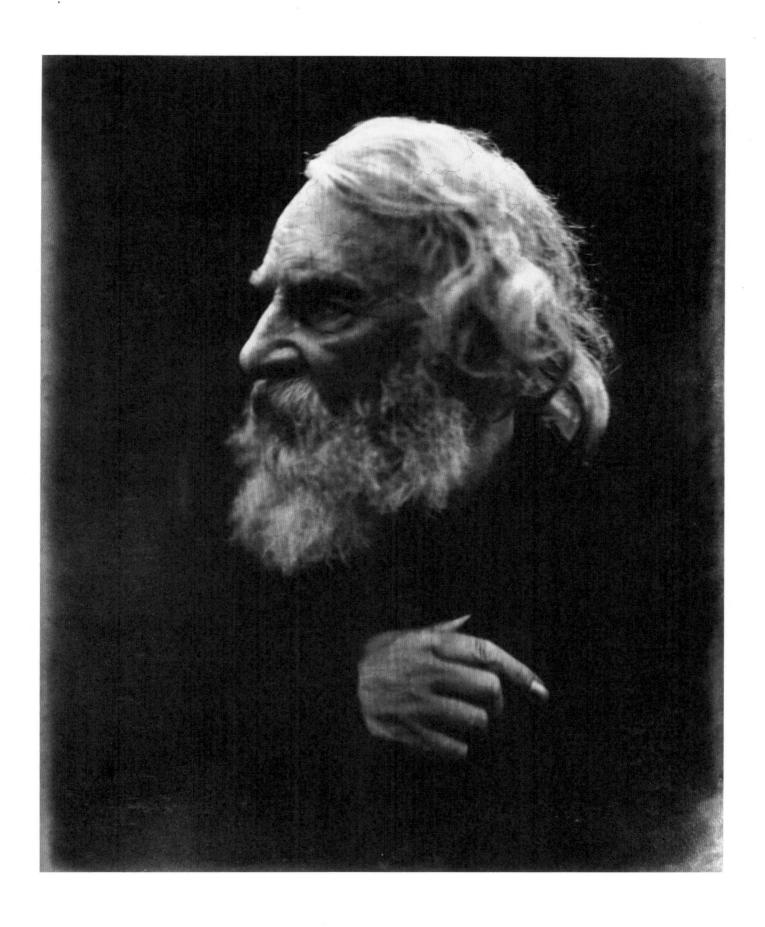

PLATE 4

ALFRED TENNYSON (1809–1902)

"'The dirty monk', so called by the Laureate with
whom this portrait is a favorite (sic)."

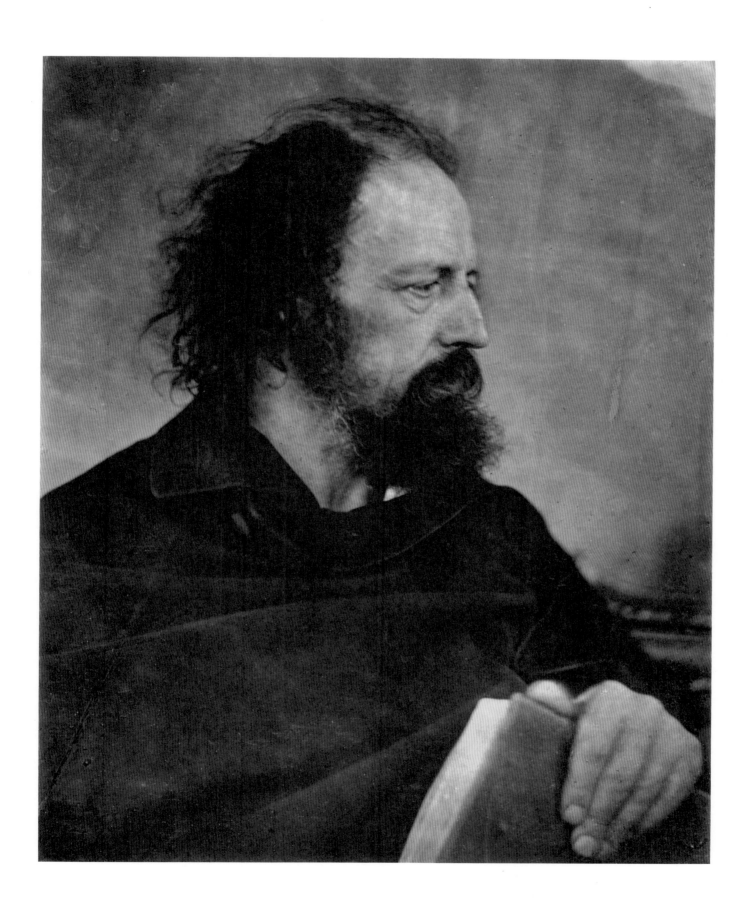

PLATE 5
ROBERT BROWNING (1812–1889)

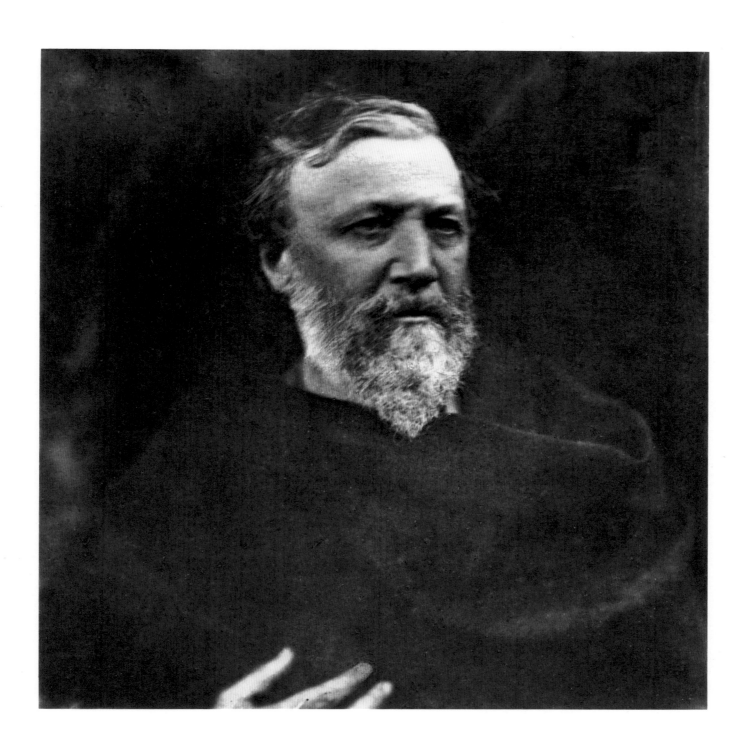

PLATE 6

G. F. WATTS (1817–1904)

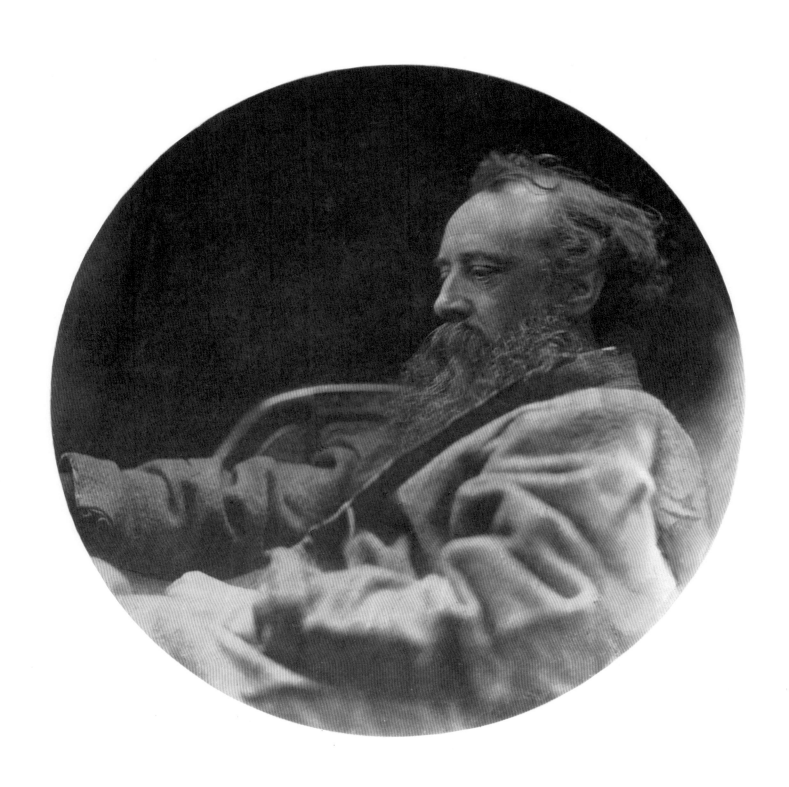

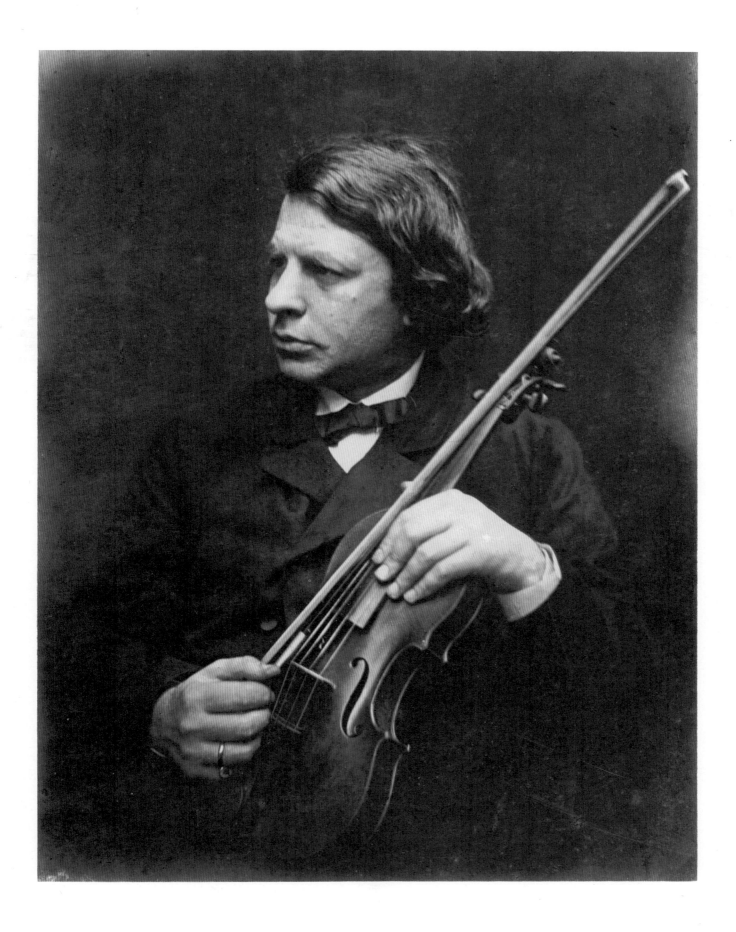

PLATE 8

PROFESSOR JOWETT (1817–1893)

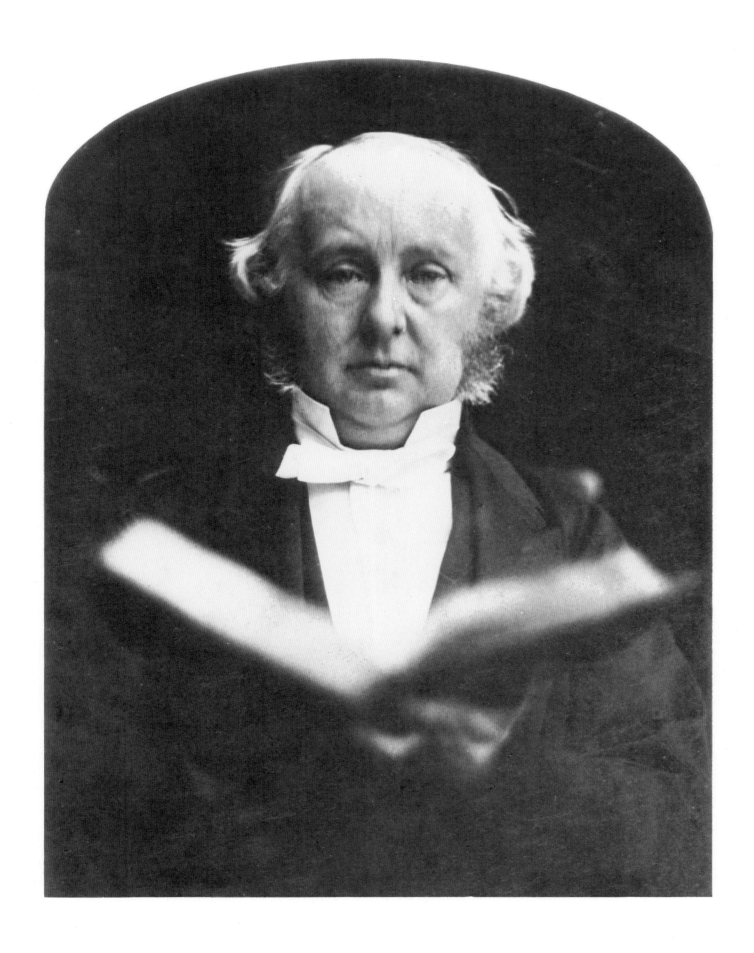

PLATE 9
CHARLES DARWIN (1809–1882)

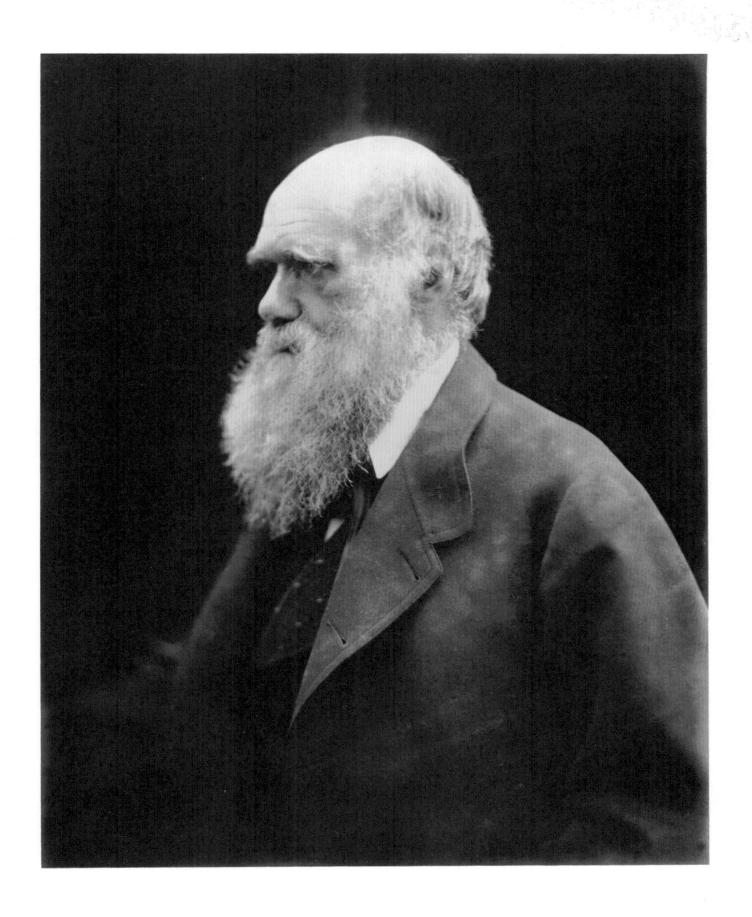

PLATE 10

THOMAS CARLYLE (1795–1881)

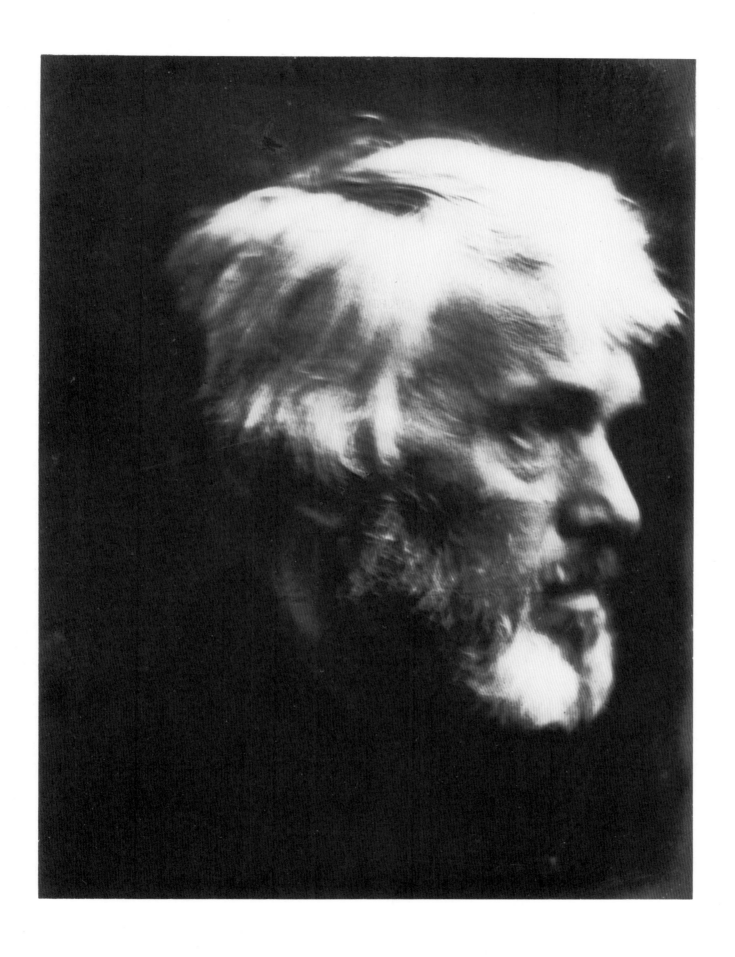

PLATE 11
JOSEPH D. HOOKER (1817–1911)

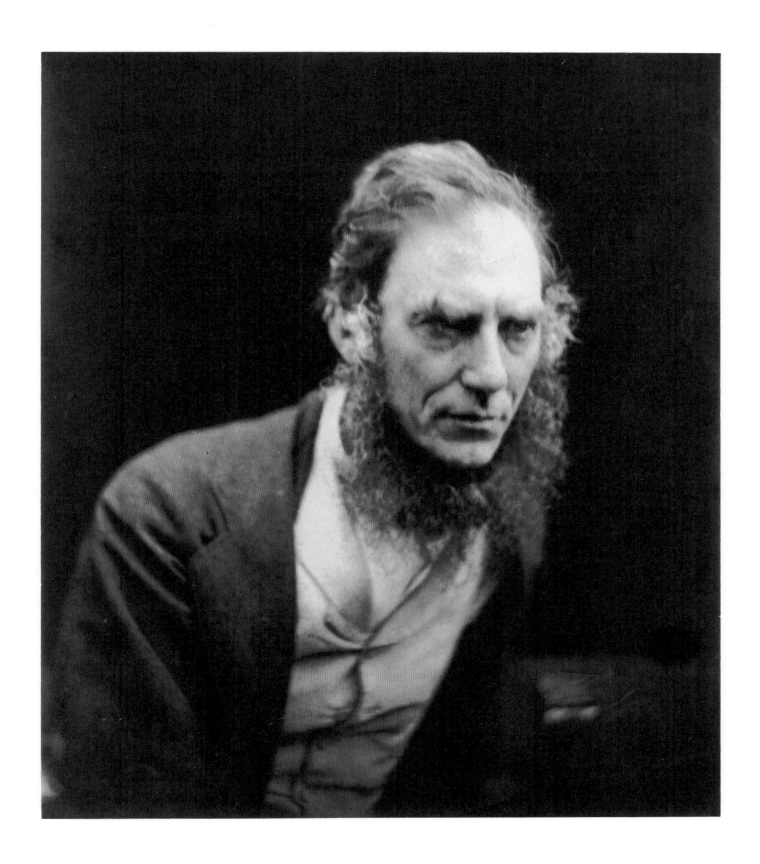

PLATE 12

SIR HENRY TAYLOR (1800–1886)

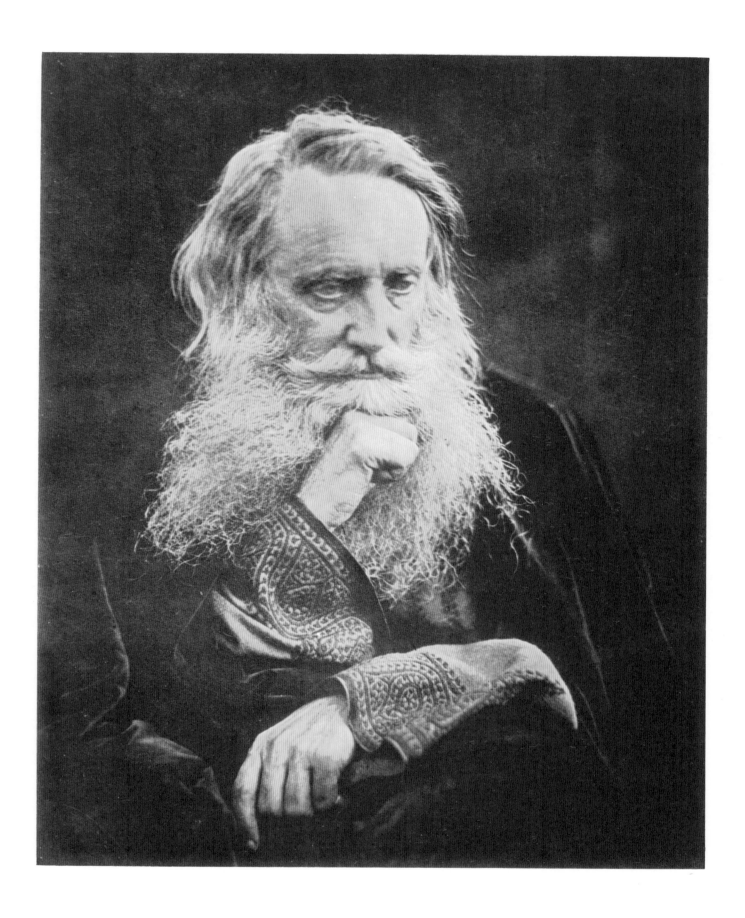

PLATE 13

FRANK CHARTERIS (1844–1870)

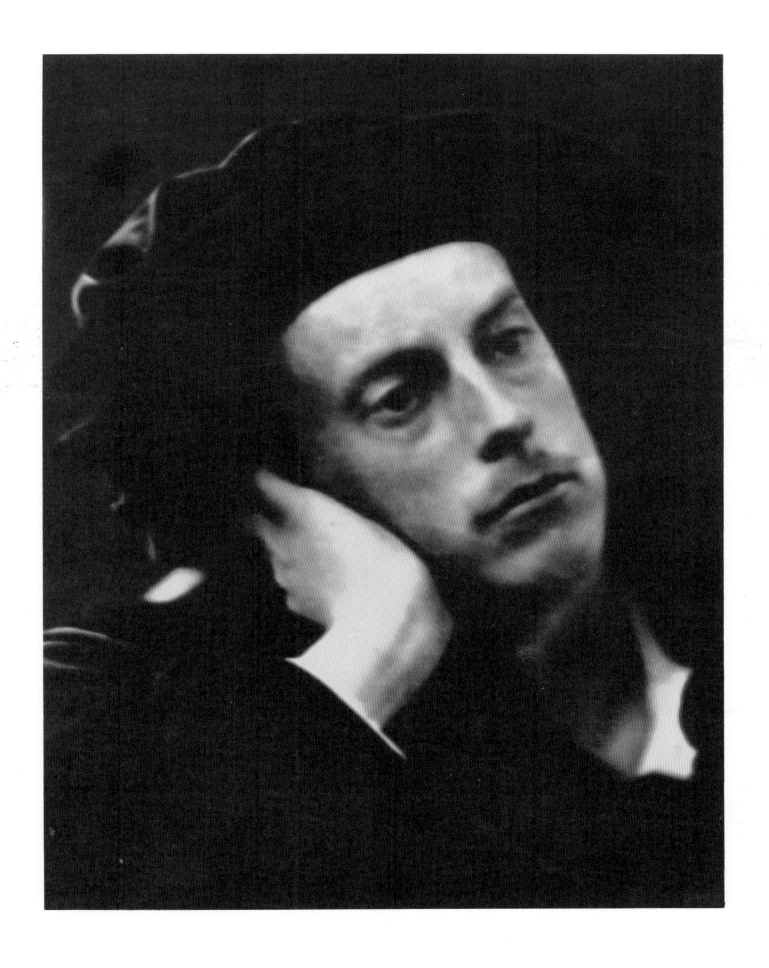

PLATE 14

'SISTERS'

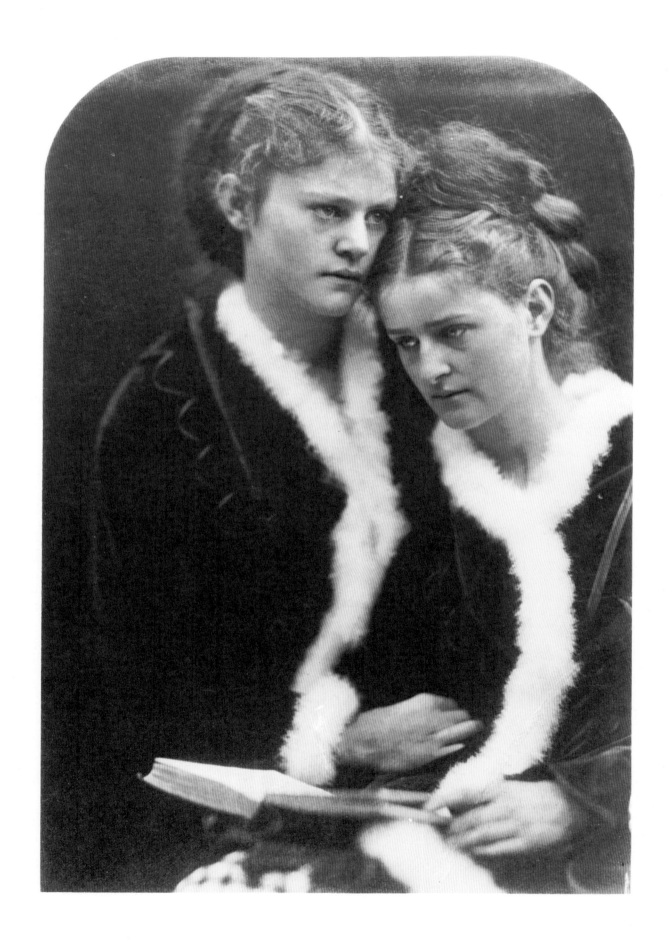

PLATE 15

MRS. LESLIE STEPHEN
(MRS. HERBERT DUCKWORTH)

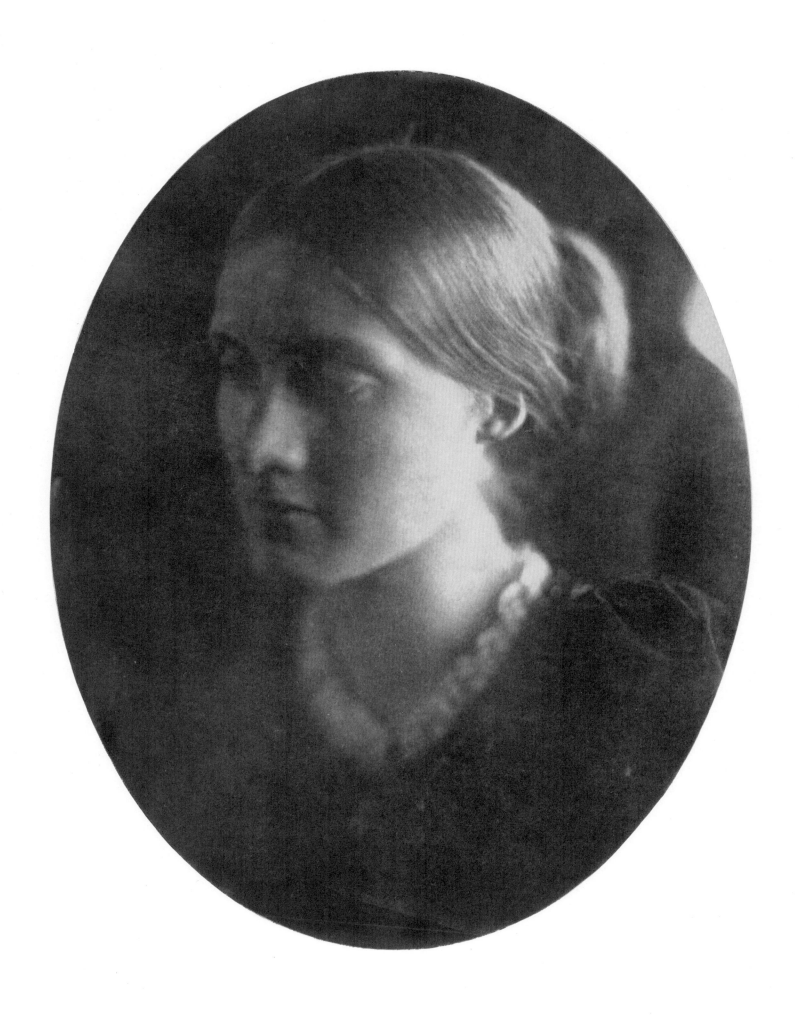

PLATE 16
MRS. LESLIE STEPHEN
(MRS. HERBERT DUCKWORTH)

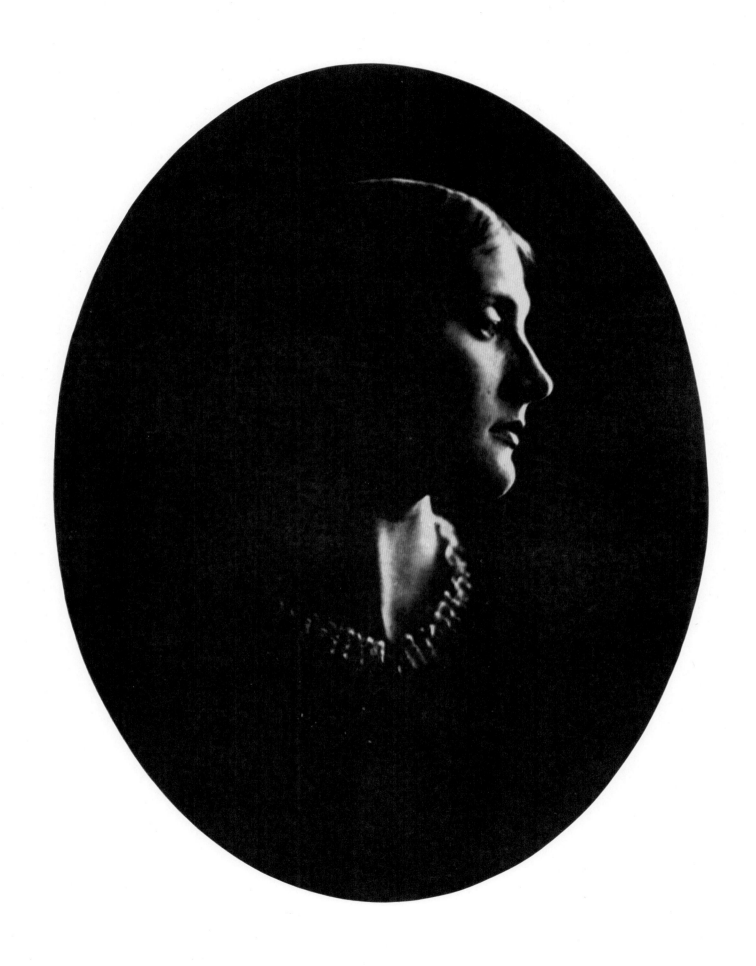

PLATE 17

'THE CHRIST KIND' (MARGIE THACKERAY)

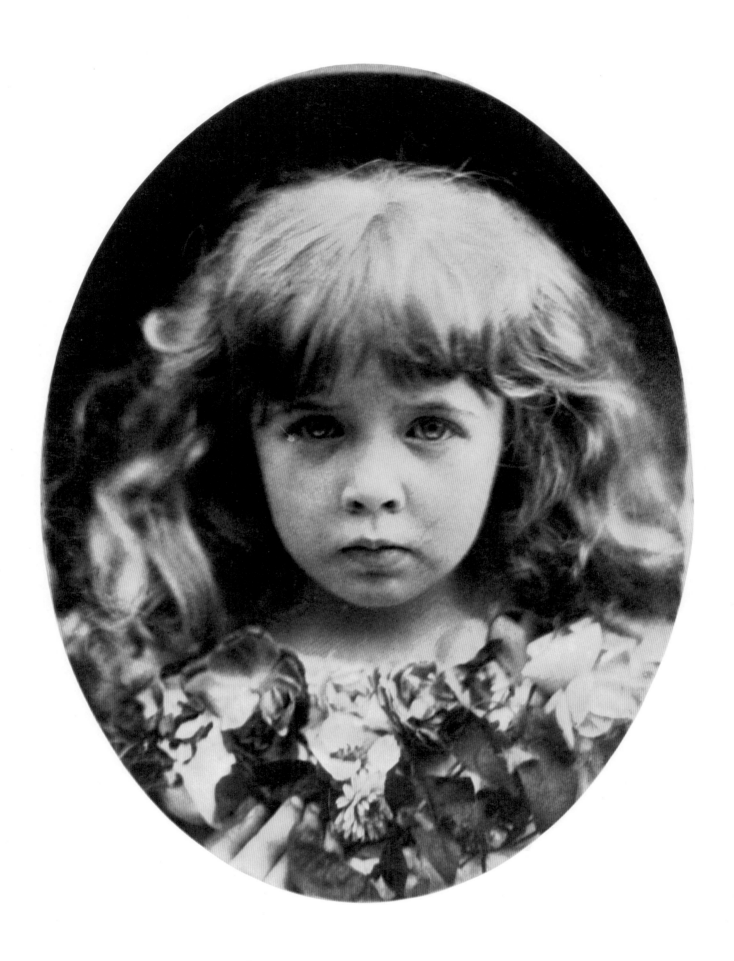

PLATE 18
'MARY MOTHER' (MAY HILLIER)

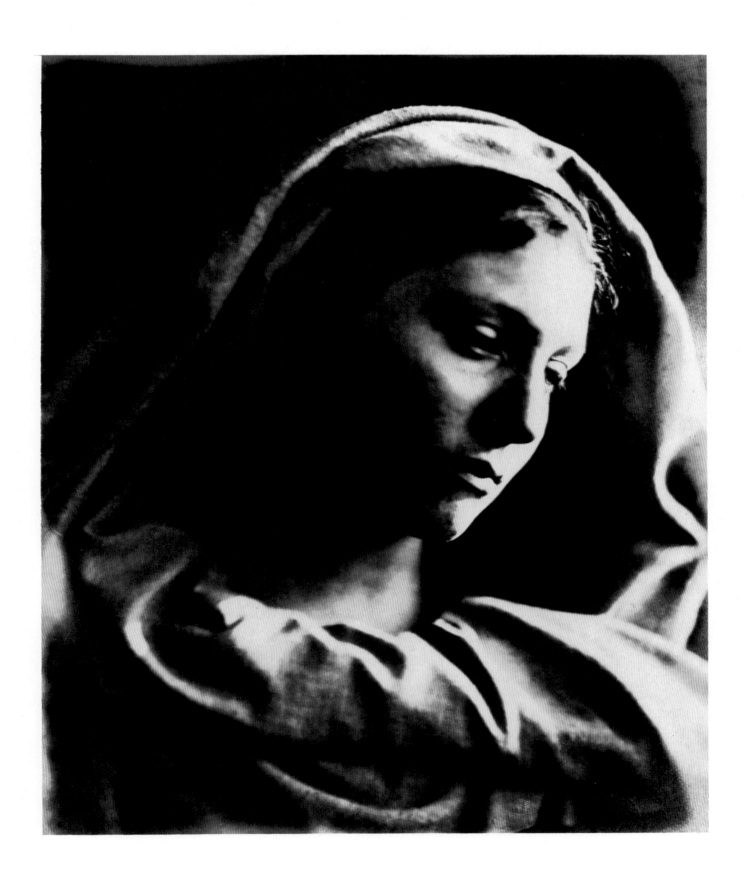

PLATE 19
C. H. CAMERON

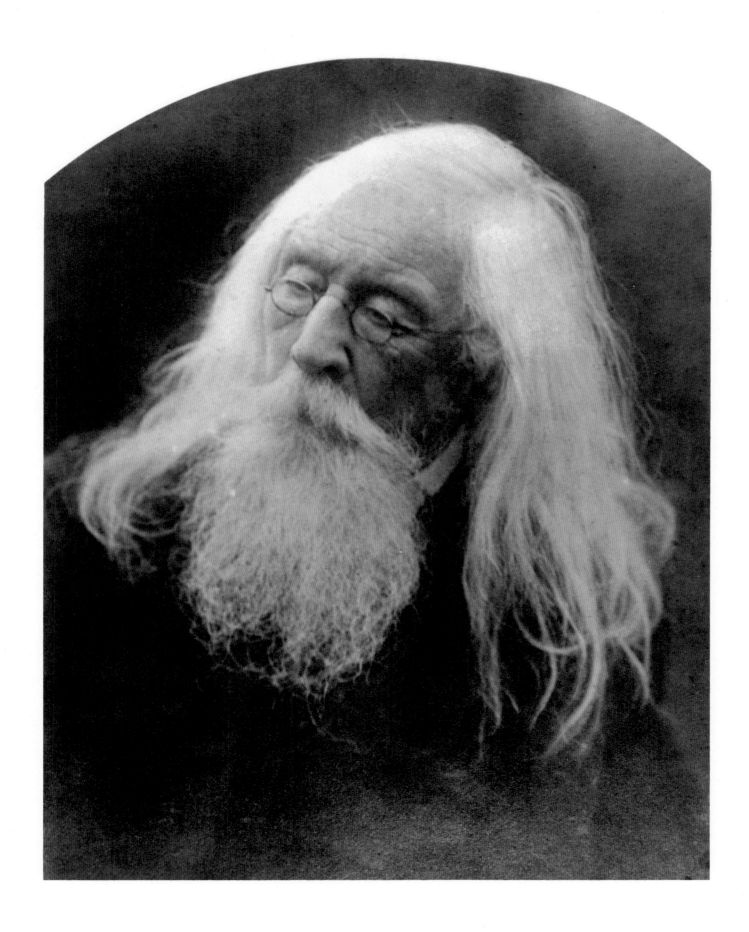

PLATE 20

'SAPPHO' (MAY HILLIER)

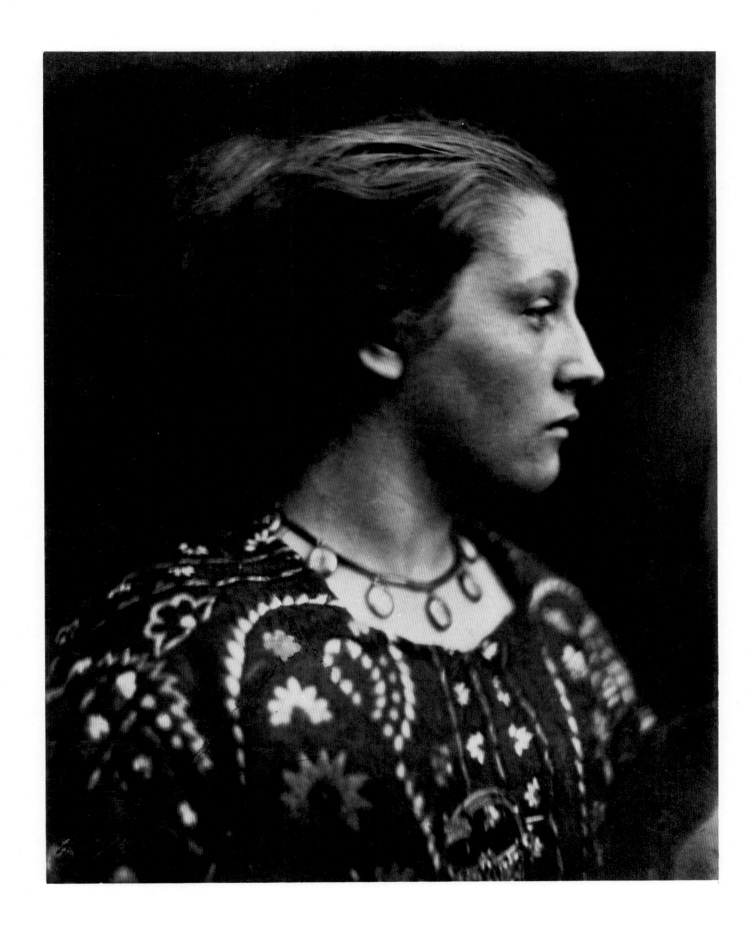

PLATE 21

'THE ECHO'

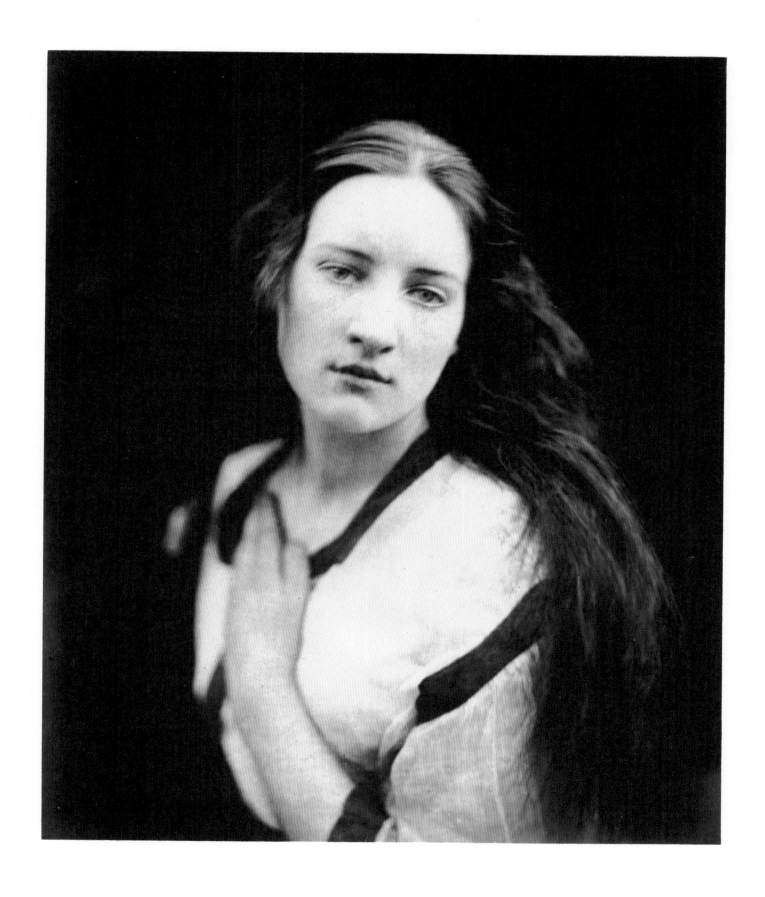

PLATE 22

'ROSEBUD GARDEN OF GIRLS'
(MRS. G. F. WATTS AND HER SISTERS)

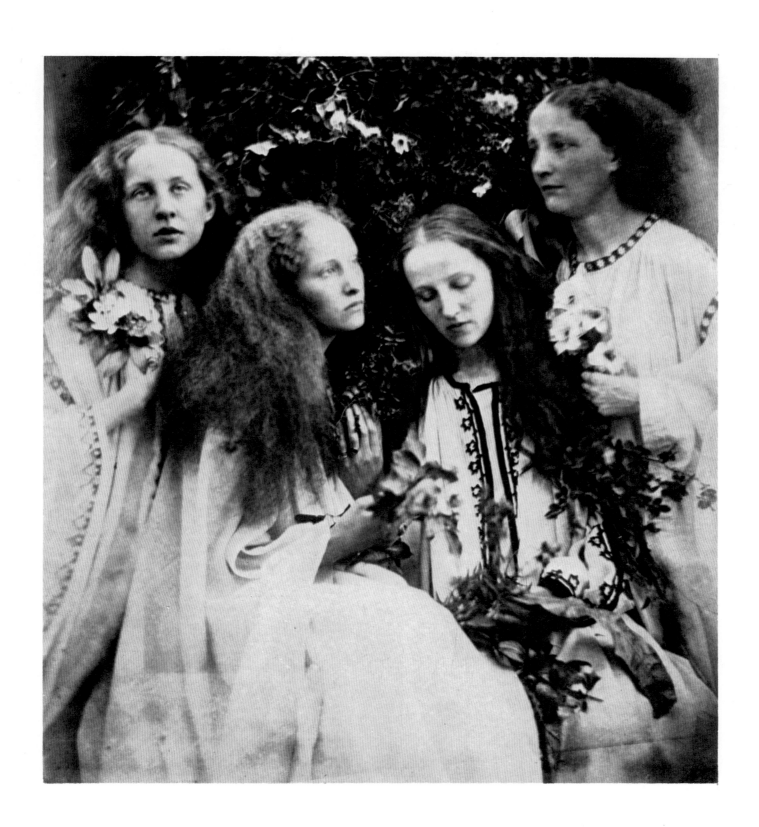

PLATE 23

'PAUL AND VIRGINIA'

(FREDDY GOULD AND LIZZIE KOEWEN)

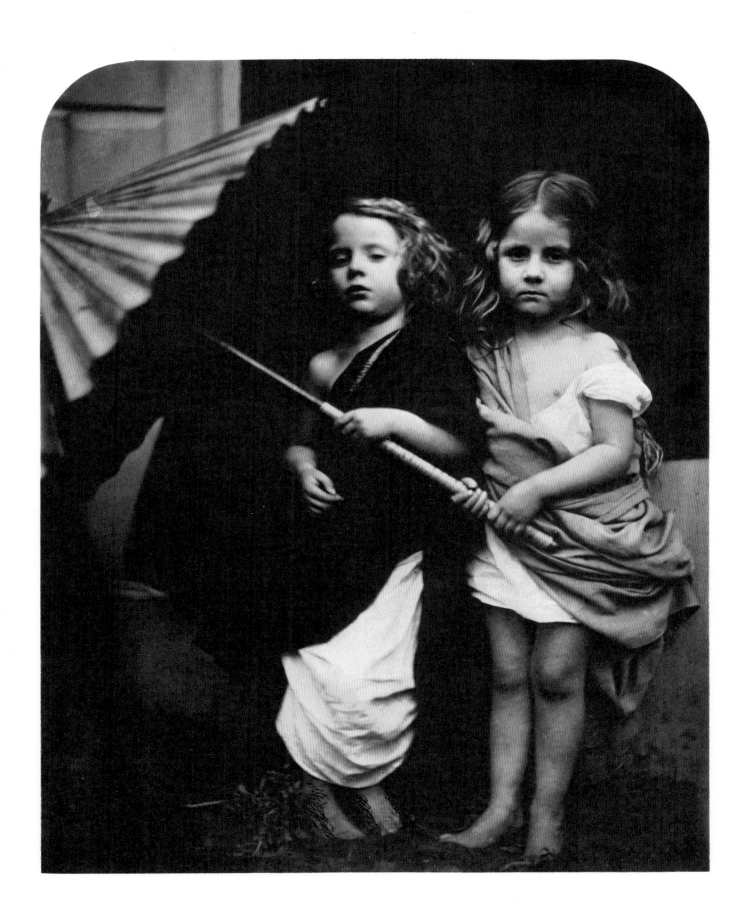

PLATE 24

'FLORENCE' (FLORENCE FISHER)

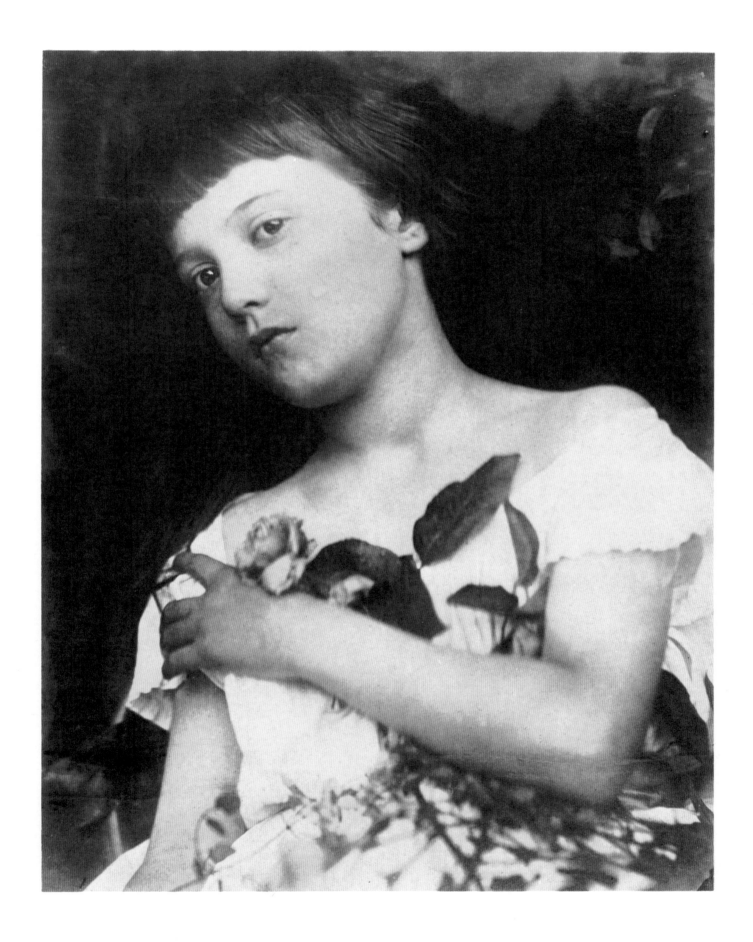

PLATE 25
W. G. PALGRAVE (1826–1888)

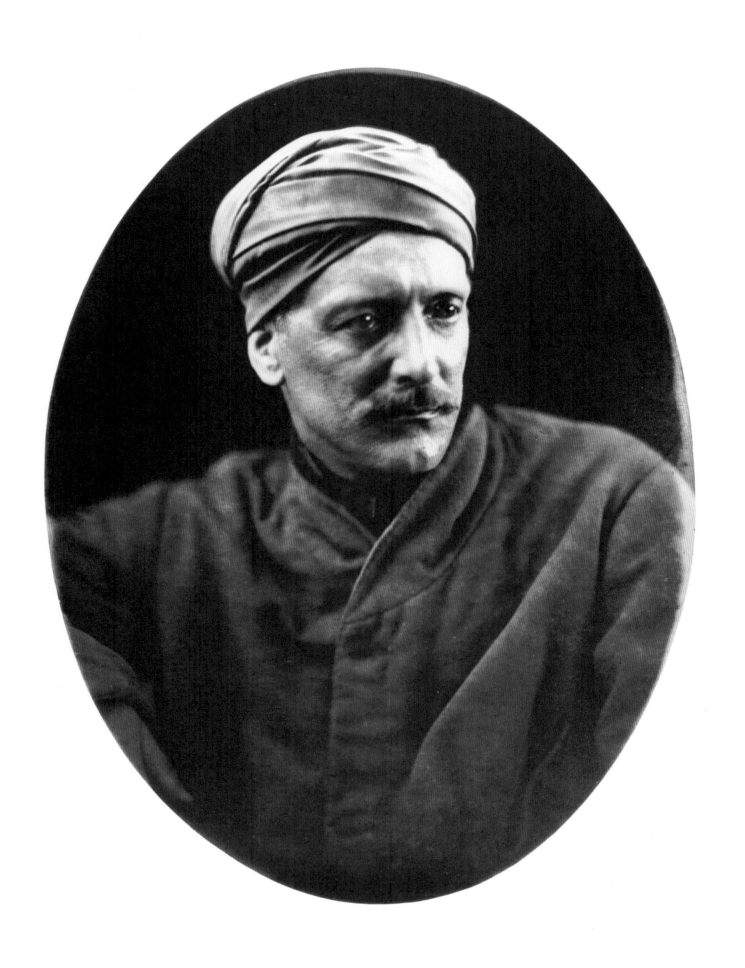

PLATE 26
ELLEN TERRY (1847–1928)

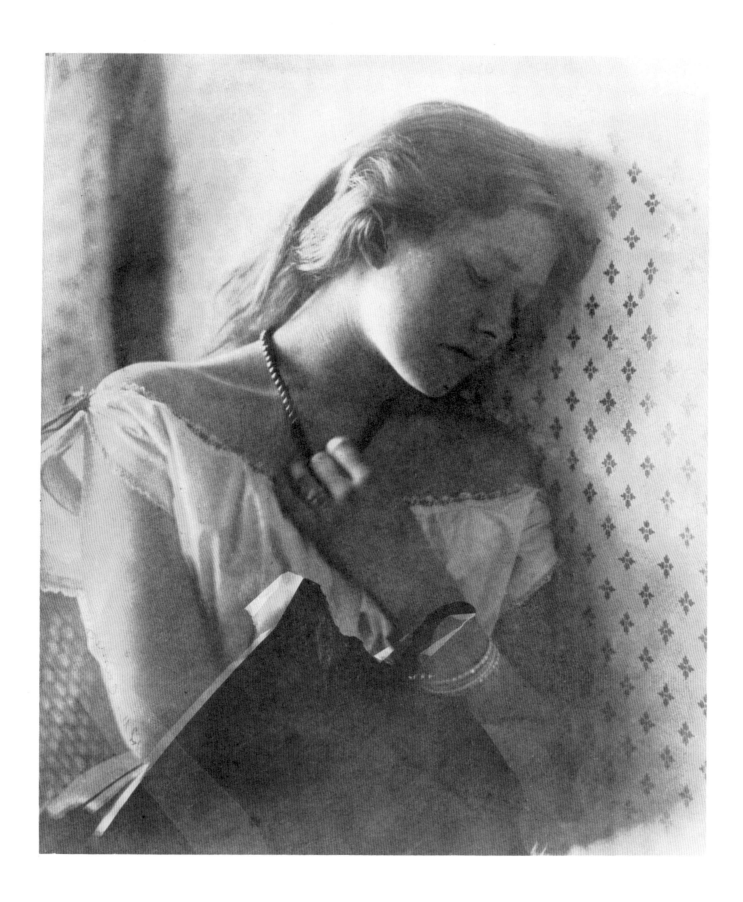

PLATE 27

'CASSIOPEIA'

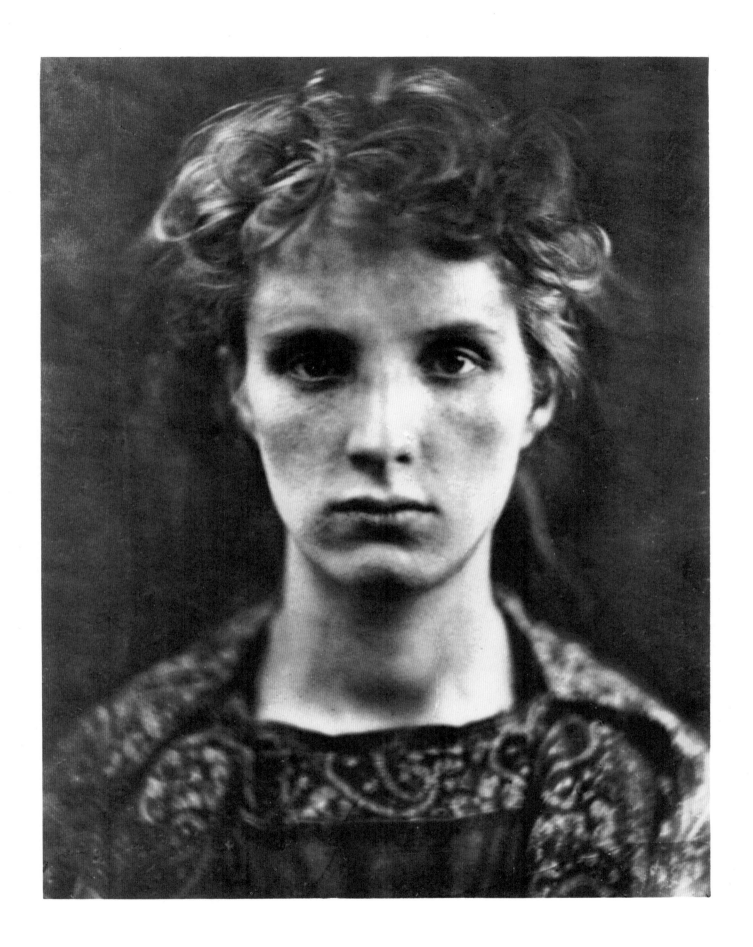

PLATE 28

'MADONNA WITH CHILD' (MAY HILLIER)

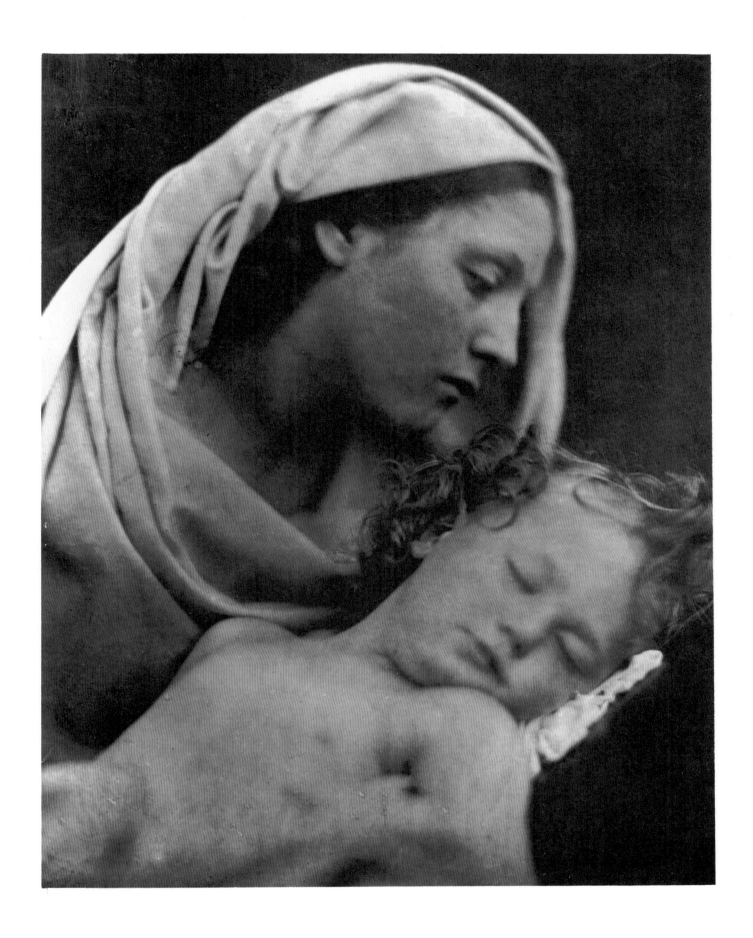

PLATE 29
'SUMMER DAYS'
MAY PRINSEP, FREDDY GOULD,
LIZZIE KOEWEN, MARY RYAN

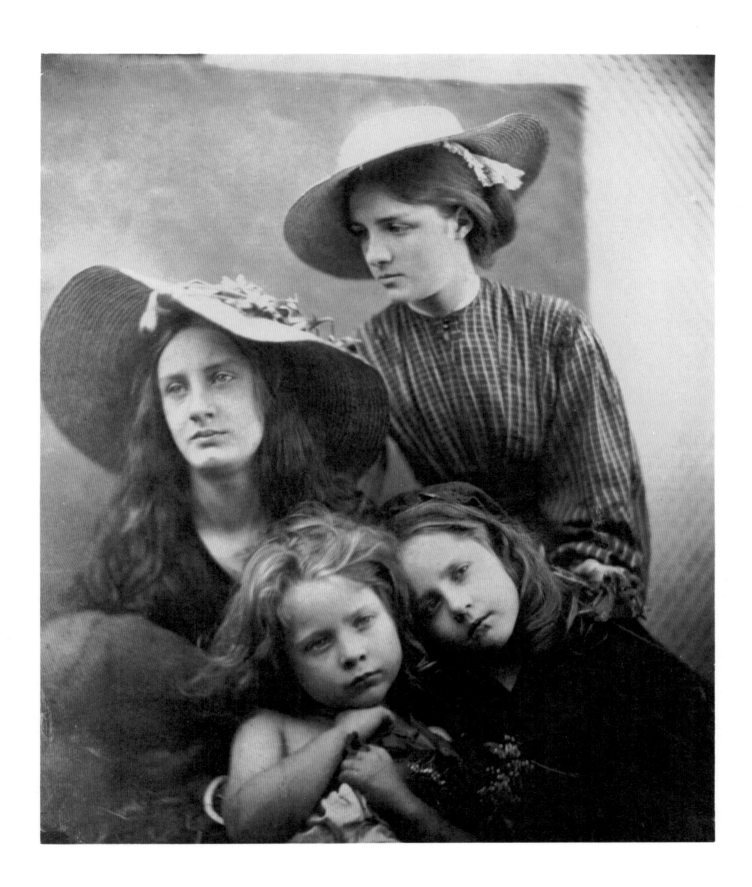

PLATE 30

MRS. DUCKWORTH AT SAXONBURY (1872)

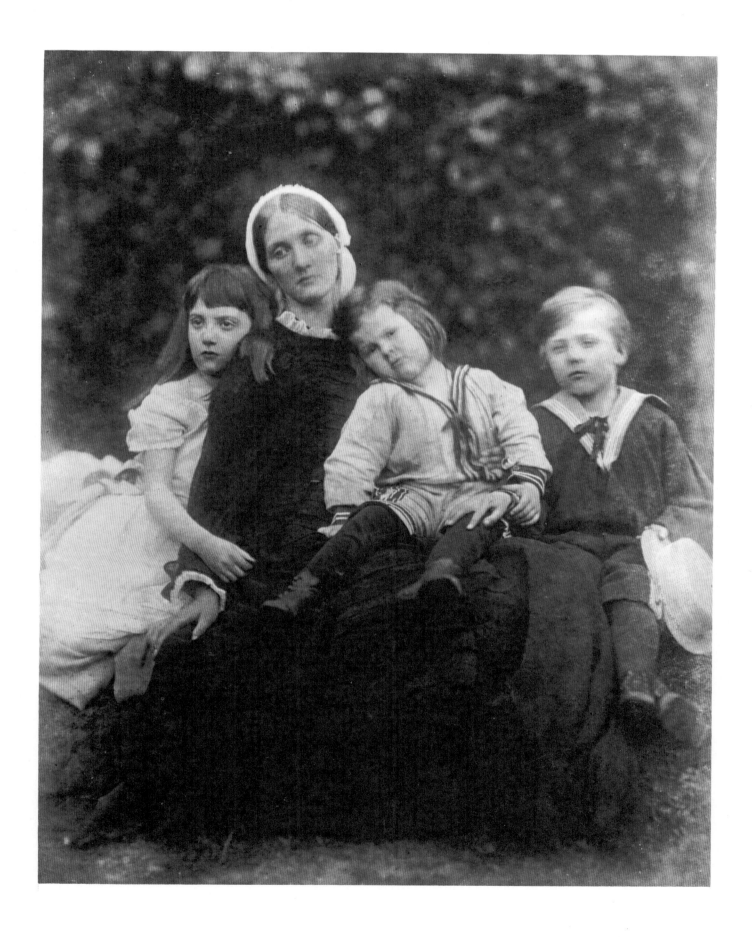

PLATE 31
LAURA AND RACHEL GURNEY

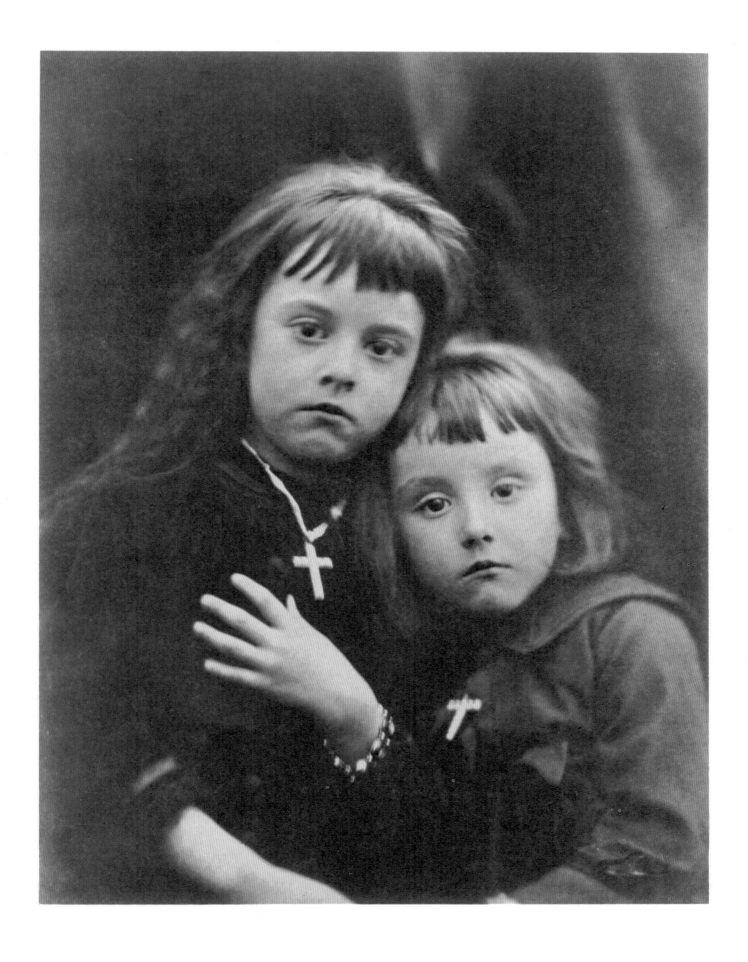

PLATE 32

'DEATH OF ELAINE'

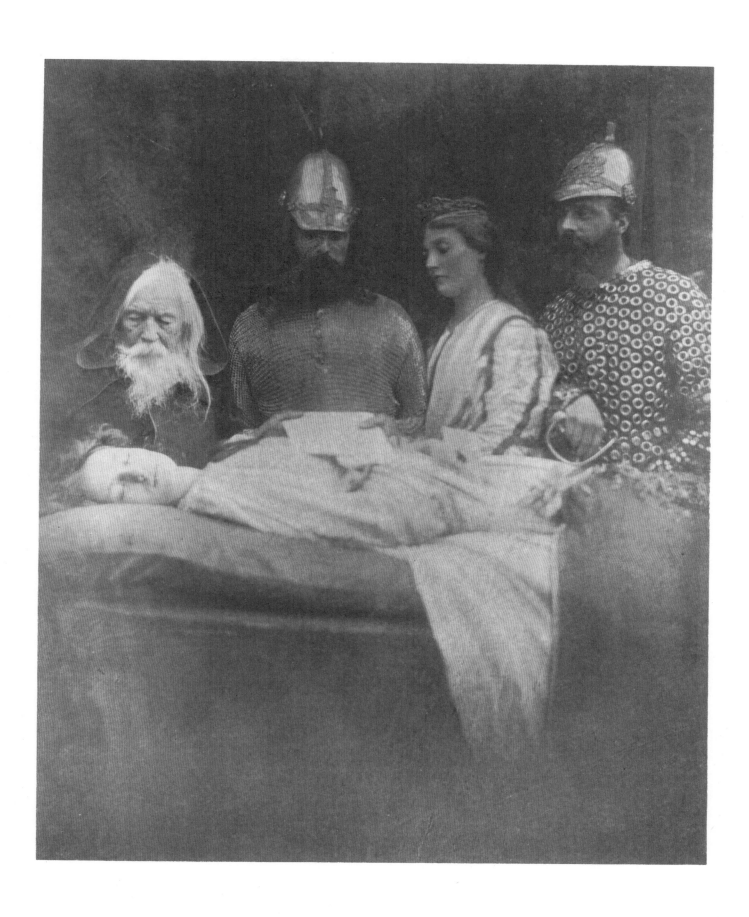

PLATE 33

'PRAY GOD BRING FATHER SAFELY HOME'

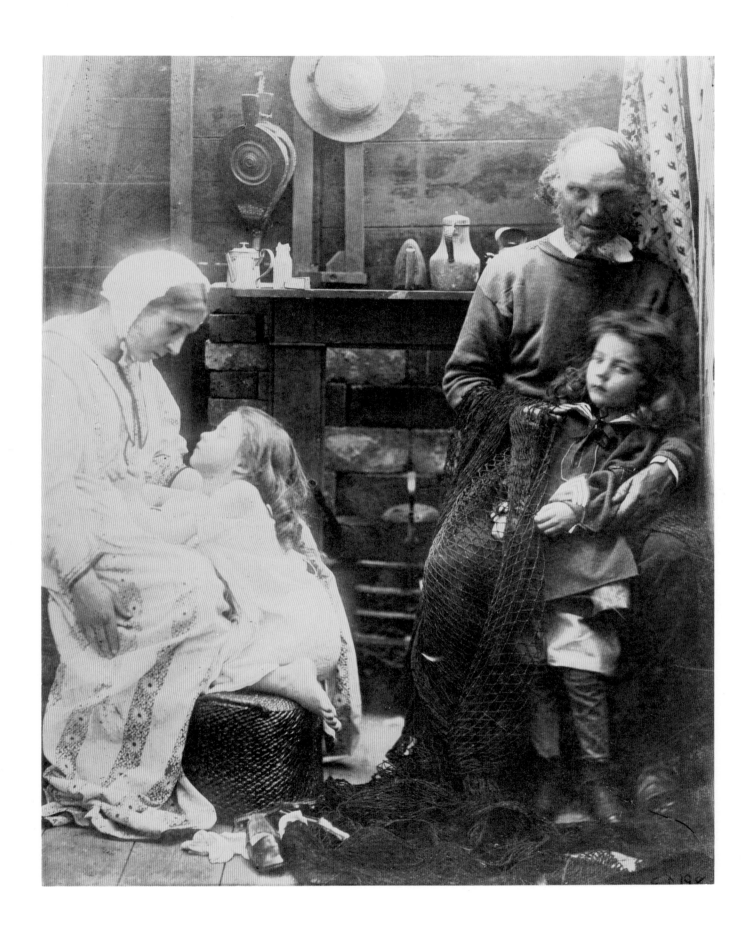

PLATE 34

CAPTAIN SPEEDY, PRINCE ALAMAYU OF
ABYSSINIA AND CASA THE SERVANT (1868)

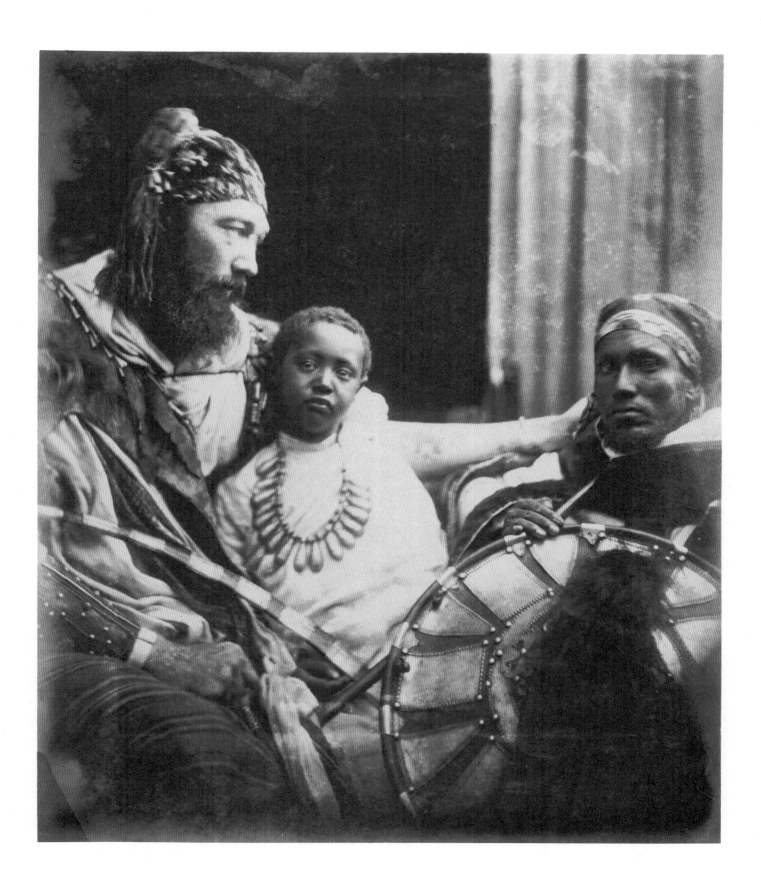

PLATE 35

'JOHN THE BAPTIST'

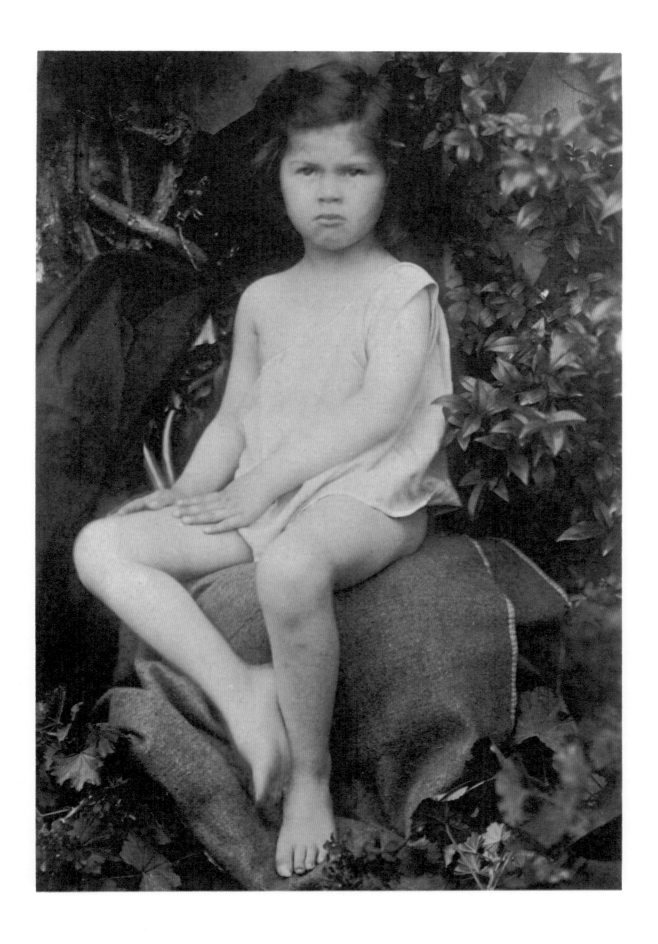

PLATE 36

'THE WANDERING MINSTRELS'
(MARY RYAN, KATIE AND LIZZIE KOEWEN)

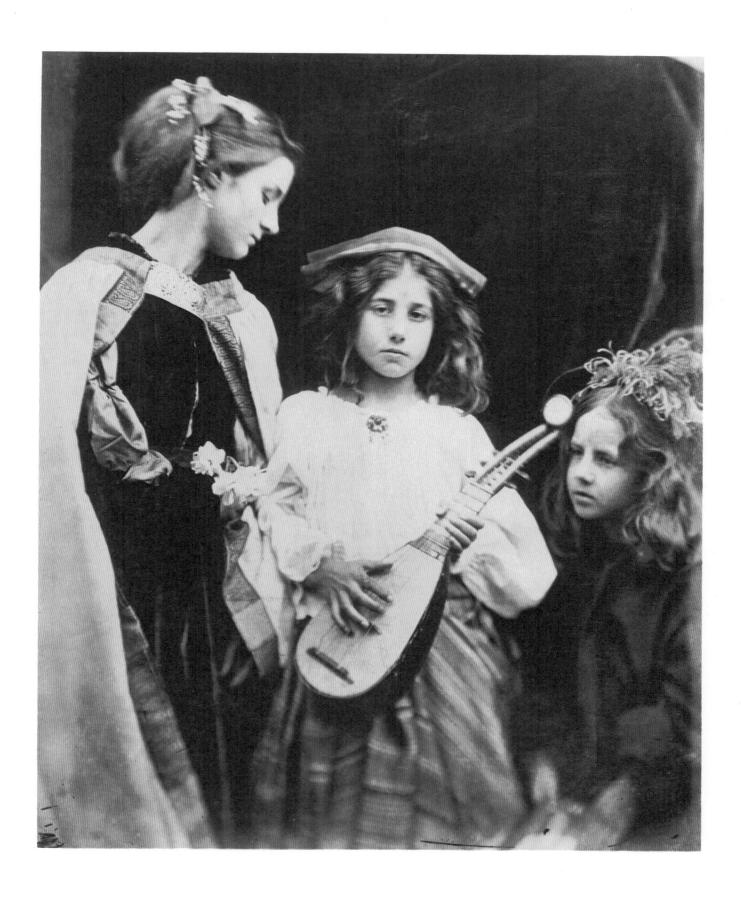

PLATE 37

'CHRISTABEL'
(MAY PRINSEP AT THE AGE OF 14)

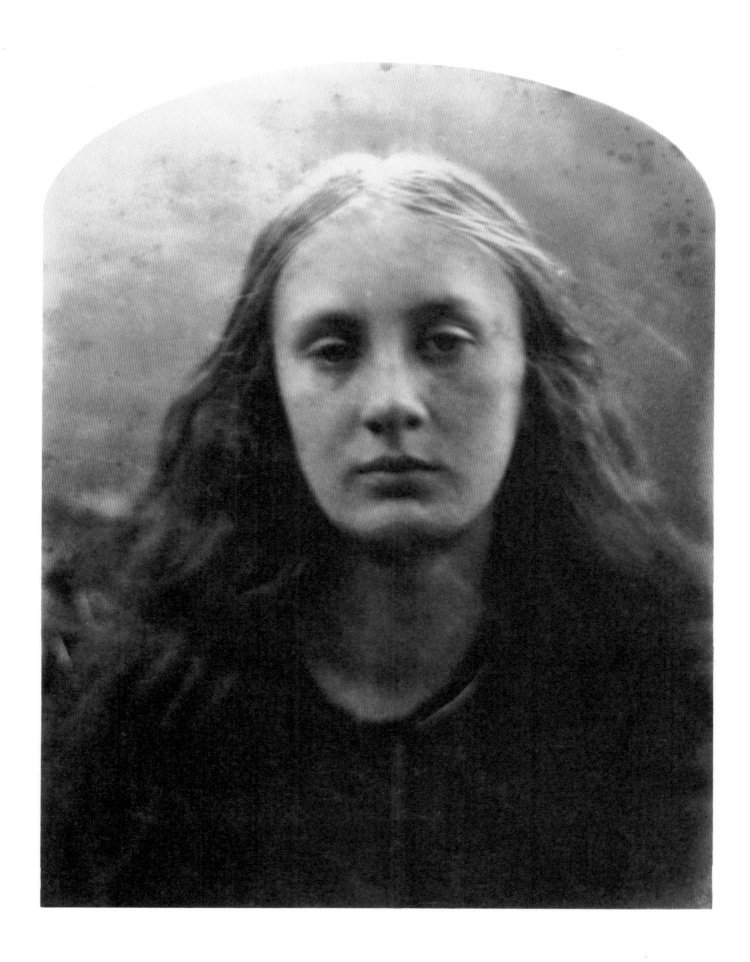

PLATE 38

ALFRED TENNYSON (1809–1902)

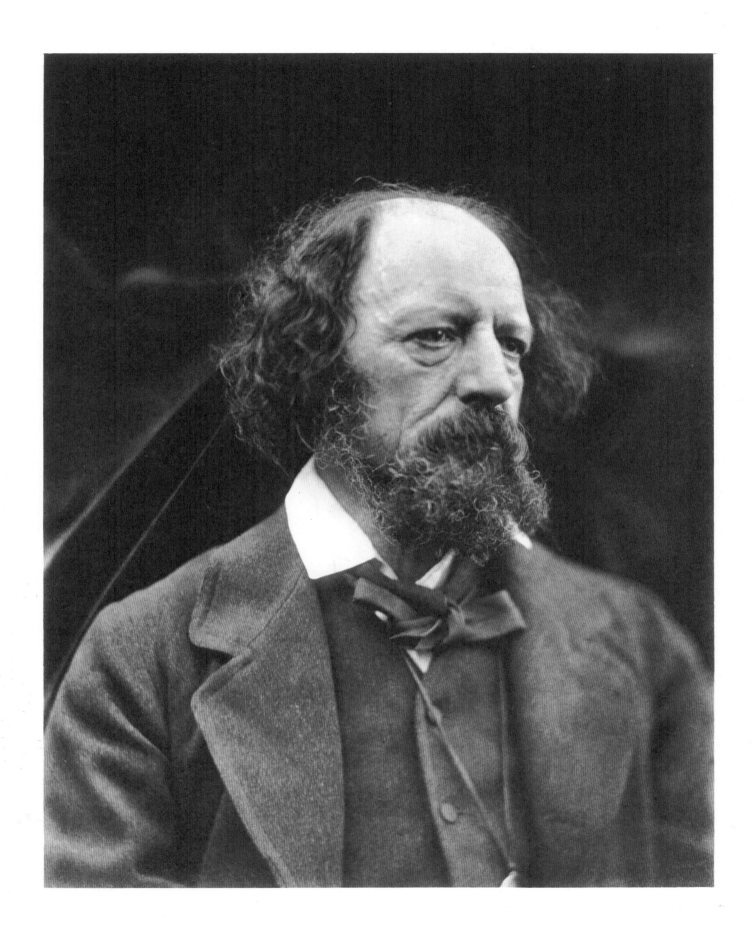

PLATE 39
JULIA CAMERON

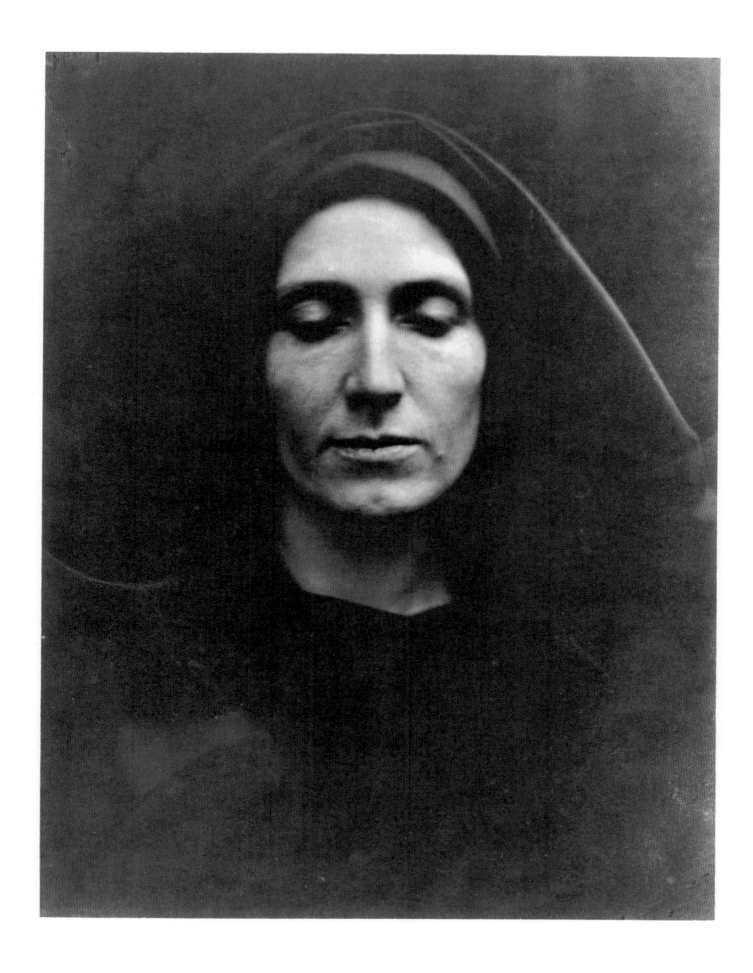

PLÀTE 40

'STUDY OF BEATRICE' (MAY PRINSEP)

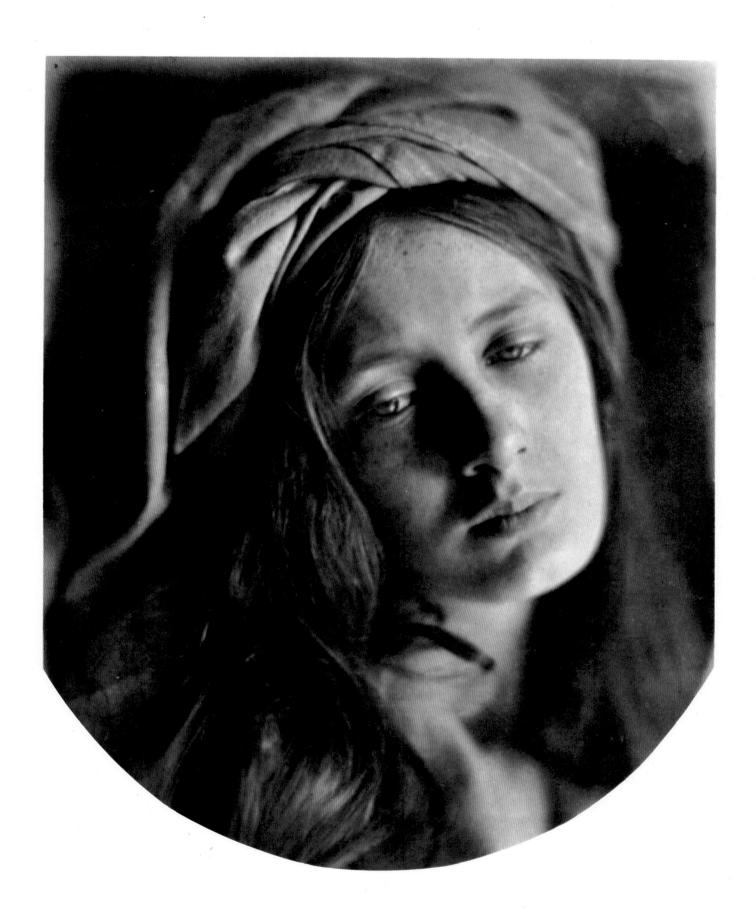

PLATE 41

PRINCE ALAMAYU OF ABYSSINIA

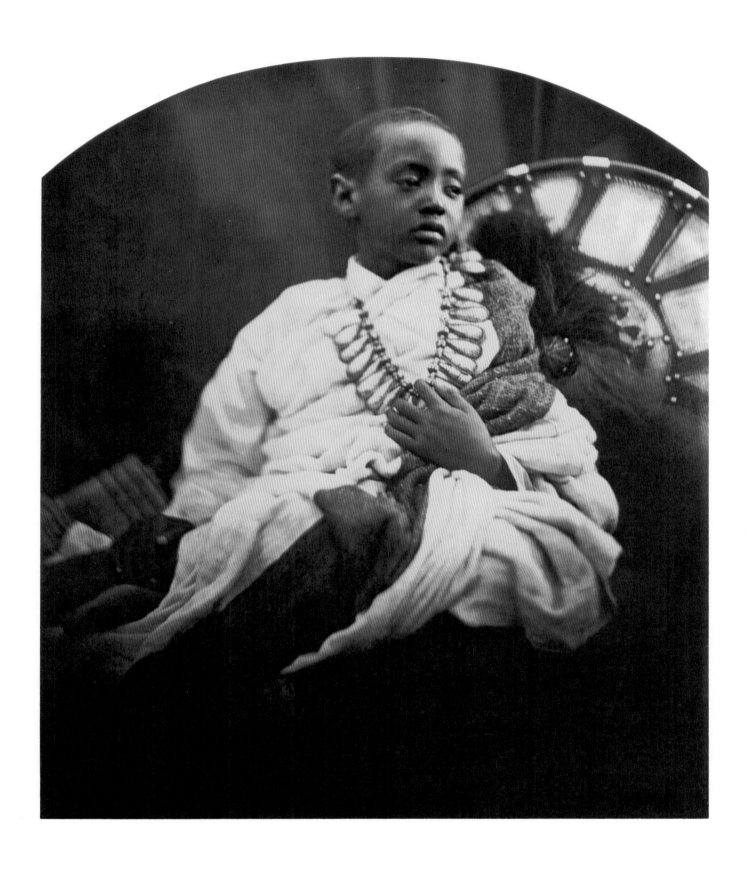

PLATE 42

LIONEL TENNYSON

"Lionel Tennyson in the character of Marquis de St. Cash has acted in *Payable on Demand* at the private theatricals at Mrs. Cameron's thatched house in aid of the Freshwater Village Hospital."

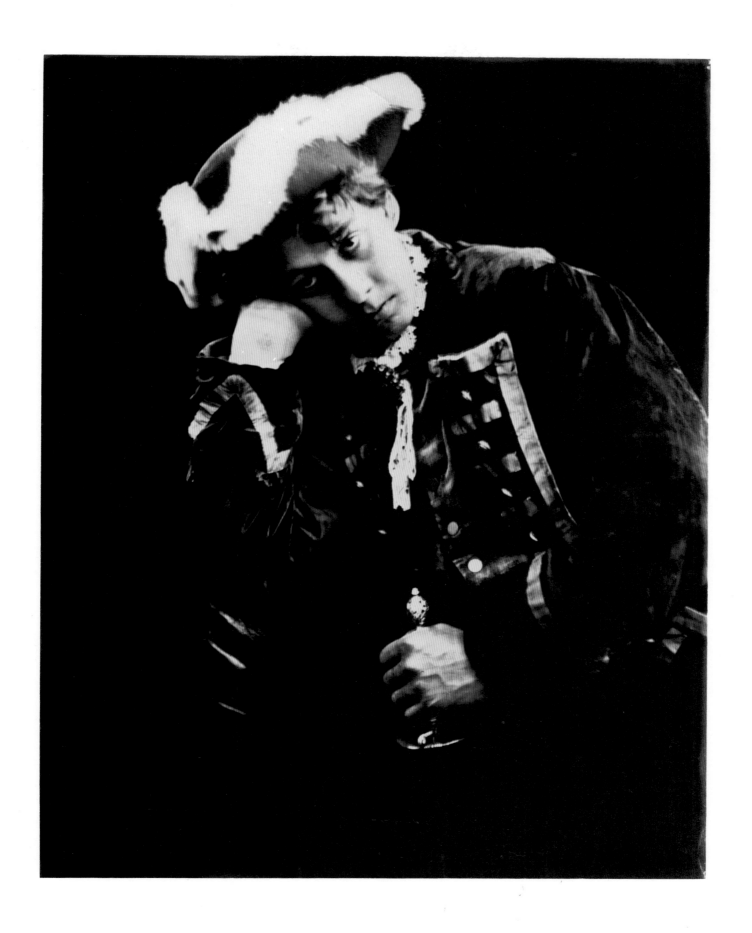

PLATE 43
'THE WHITE ROSES'
(KATIE AND LIZZIE KOEWEN)

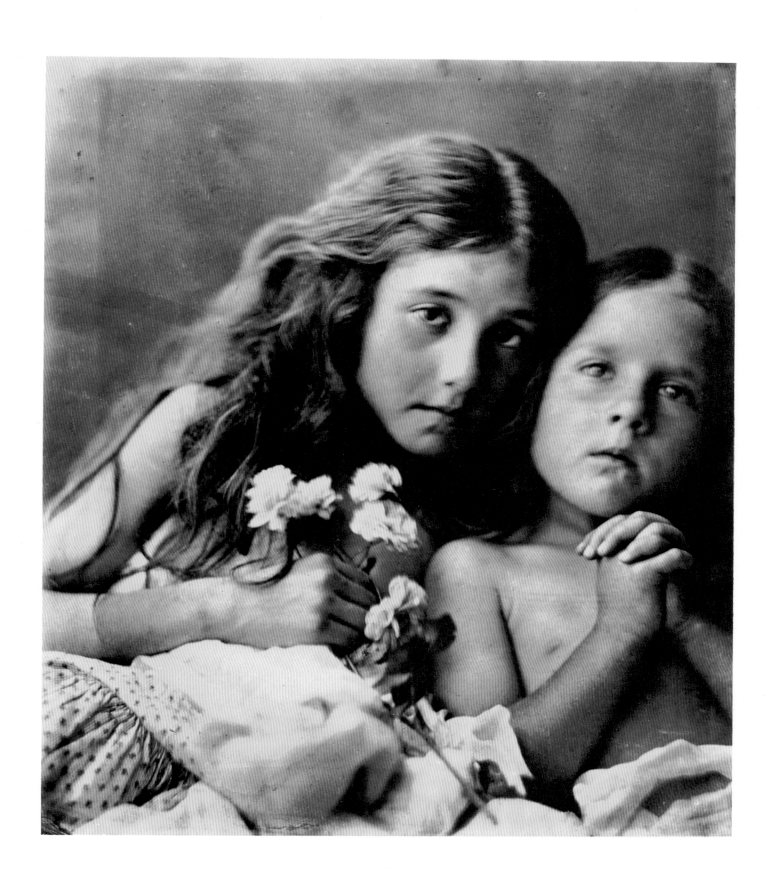

PLATE 44

'A REMBRANDT' (SIR HENRY TAYLOR)

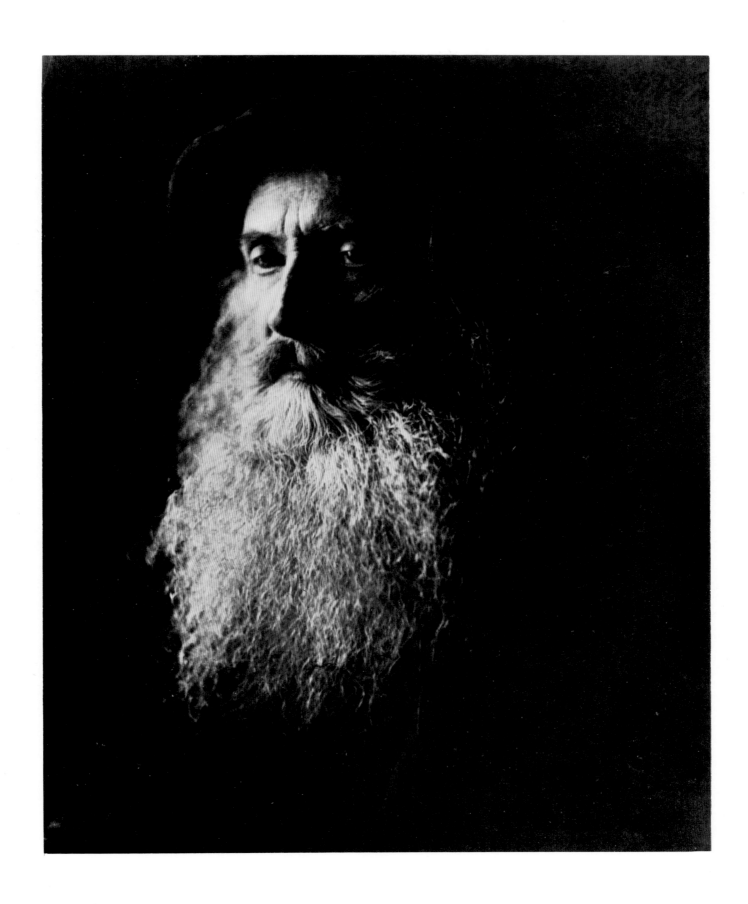